MW01012329

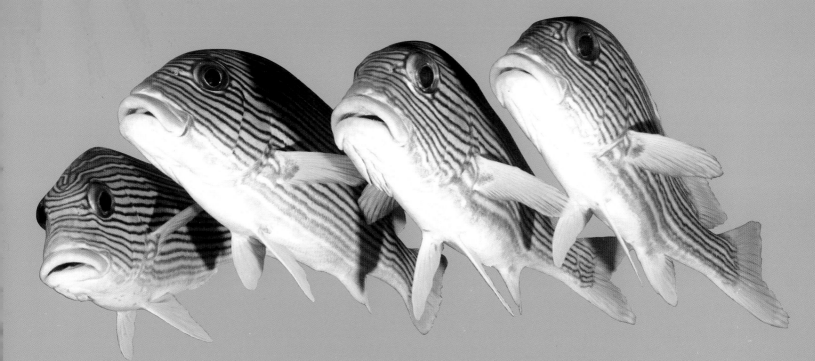

Under the Sea
POSTER BOOK

Text by
Andy Case, Mark Faulkner, and Edward Seidel
of Tenji, Inc.

Do you know what covers most of the Earth's surface? It's not land — it's water! Big, deep oceans are home to millions of fabulous sea creatures. Maybe you've seen some of them up close when you've visited the ocean or an aquarium. Or, perhaps you even have your own fish tank at home where you can closely observe the daily habits of a few fish. Now, with these posters, you can wake up every day to look even more strange-looking fish and salt-water animals straight in the eye and learn all about how they live, eat, and move under the sea.

There are so many animals in the ocean that scientists haven't even discovered all of them yet. These animals form a complex and diverse community. Some of them have very special relationships with each other, which you will learn about in the following pages. For instance, the nudibranch (sea slug) steals stinging cells from other animals to use for its own protection. Sea anemones provide protection for clownfish, while the clownfish chase off any would-be predators of the sea anemone. Cleaner shrimp are the dentists of the undersea world, slipping into the mouths of larger fish to clean away the debris from their teeth.

Saltwater animals also have a special relationship with us. We learn a lot about our world by studying them, and we enjoy looking at pictures of them, seeing them in an aquarium, or observing them in their natural habitat when we dive in with a snorkel and flippers. We also help the sea creatures stay alive and healthy by protecting them and keeping the oceans clean.

So, get ready for a big splash and enjoy your encounter with life under the sea!

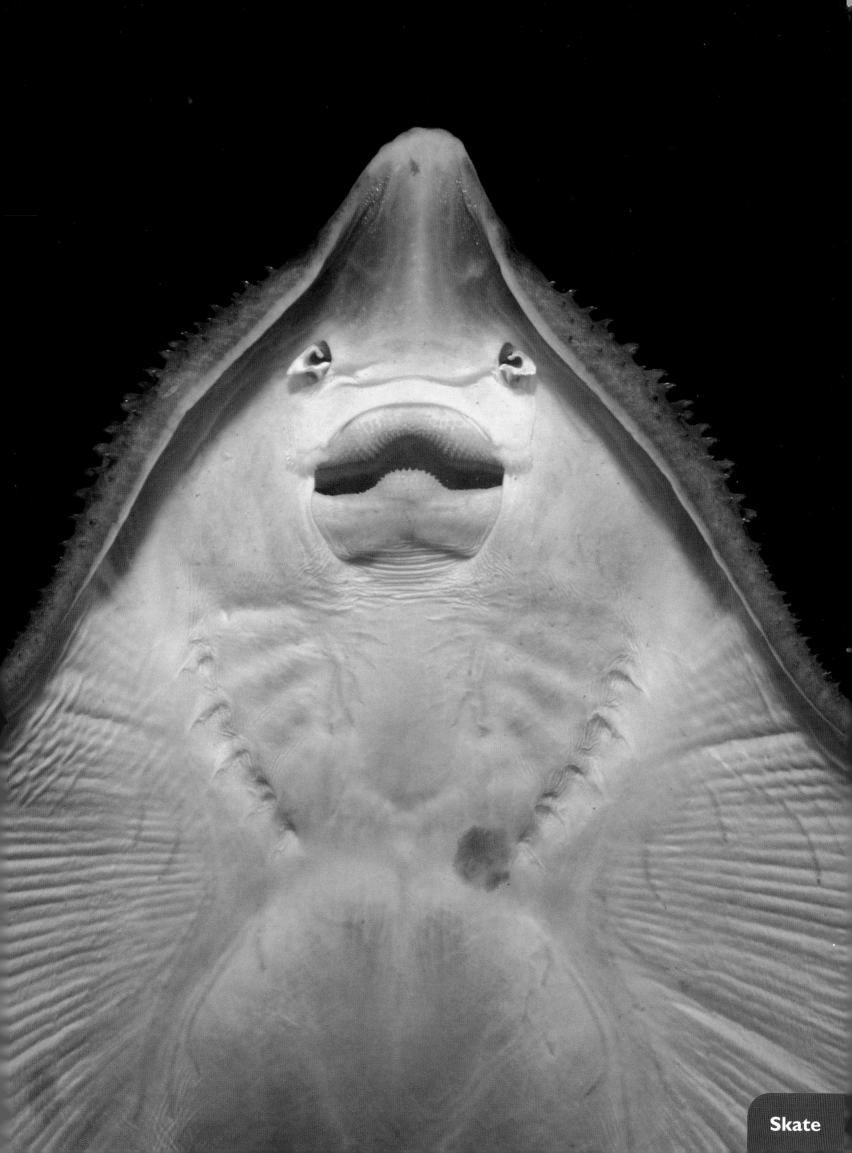

Skate

Skate

• • • • • • • • • • •

The weird-looking creature in the picture is an interesting fish called a skate. We are seeing it from the underneath side. The sideways opening is its mouth and the two little holes above the mouth are its nostrils.

Toothy Relative of the Shark

Skates are actually flat, gentle cousins of the more famous and toothy sharks. If you look closely at the mouth in the picture, you can see pointy little ridges on the skate's jaw. That is officially called its **dentition** (tooth pattern). See how similar that word is to *dentist*?

Low Life?

If you were to look down at a skate resting on the ocean floor, you probably wouldn't notice it. Skates are experts at blending in and will even partially bury themselves in the soft sand or mud on the bottom to hide. While harmless to humans, skates use their rough, crushing jaws to smash hard shells of clams and shrimp in order to slurp up the soft, squishy morsels inside as they hunt along the seafloor.

False Cousin of the Stingray

Although skates appear similar to their other cousins, the stingrays, and have many of the same behaviors, they are different in one important way. Skates are **oviparous** (oh-VI-pa-rus), which means they lay eggs on the bottom of the ocean, each egg holding up to six babies. The young skates hatch after a year or so. Rays are **ovoviviparous** (oh-voh-vie-VI-pa-rus), which means they hold their eggs inside their body until they hatch. The young look like little versions of their parents and can swim around as soon as their mother releases them from her body.

photo © Jeff Rotman/jeffrotman.com • *Under The Sea Poster Book,* Storey Publishing

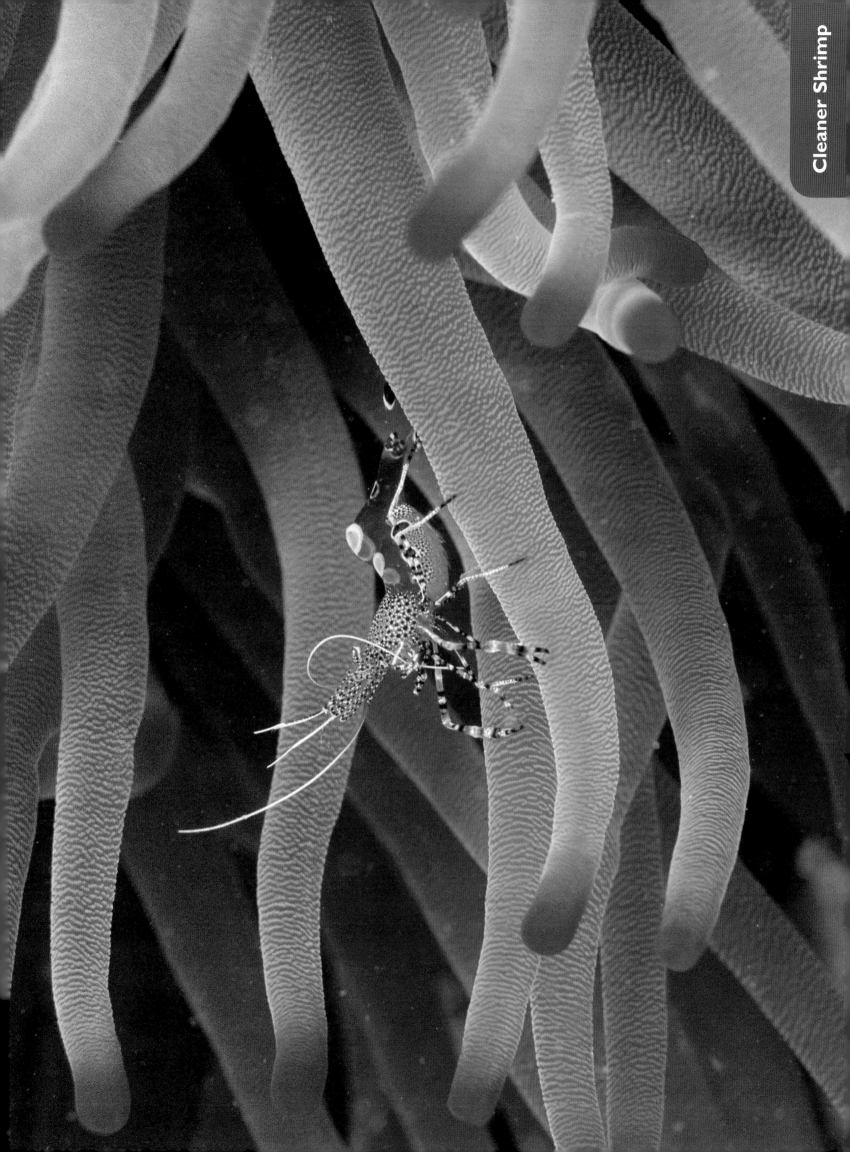

Cleaner Shrimp

Cleaner shrimp have different **appendages** (legs, claws, and antennae) for different jobs. The delicate legs of the cleaner shrimp in the picture grip the anemone without damaging it, while its front claws pick and scrape the surface. Long whiplike antennae help sense predators or a tasty meal.

Best of Friends

When two animals live closely linked lives, the relationship is called **symbiosis,** which means "living together." The cleaner shrimp and anemone's relationship benefits both of them. The shrimp protects itself from predators by nestling in the stinging tentacles of the anemone (which does not sting it). The sea anemone, in turn, is cleaned of debris.

Get in Line

Some cleaner shrimp will set up what are known as cleaning stations on the ocean floor. A shrimp will position itself on a rock, then the fish will enthusiastically line up and wait for the cleaner shrimp to crawl over their bodies, eating **parasites** (organisms that live on and eat part of another organism) and dead skin. The cleaner shrimp finds a nice meal and leaves the fish cleaner (and less itchy) than before, so both win.

Like a Dentist

Sometimes you'll see a cleaner shrimp climb into the mouth of a fish to clean there. You'd think the fish would be tempted to eat the tasty little shrimp, but it's much more interested in getting its teeth sparkling white!

photo © Mark Conlin/SeaPics.com • *Under The Sea Poster Book,* Storey Publishing

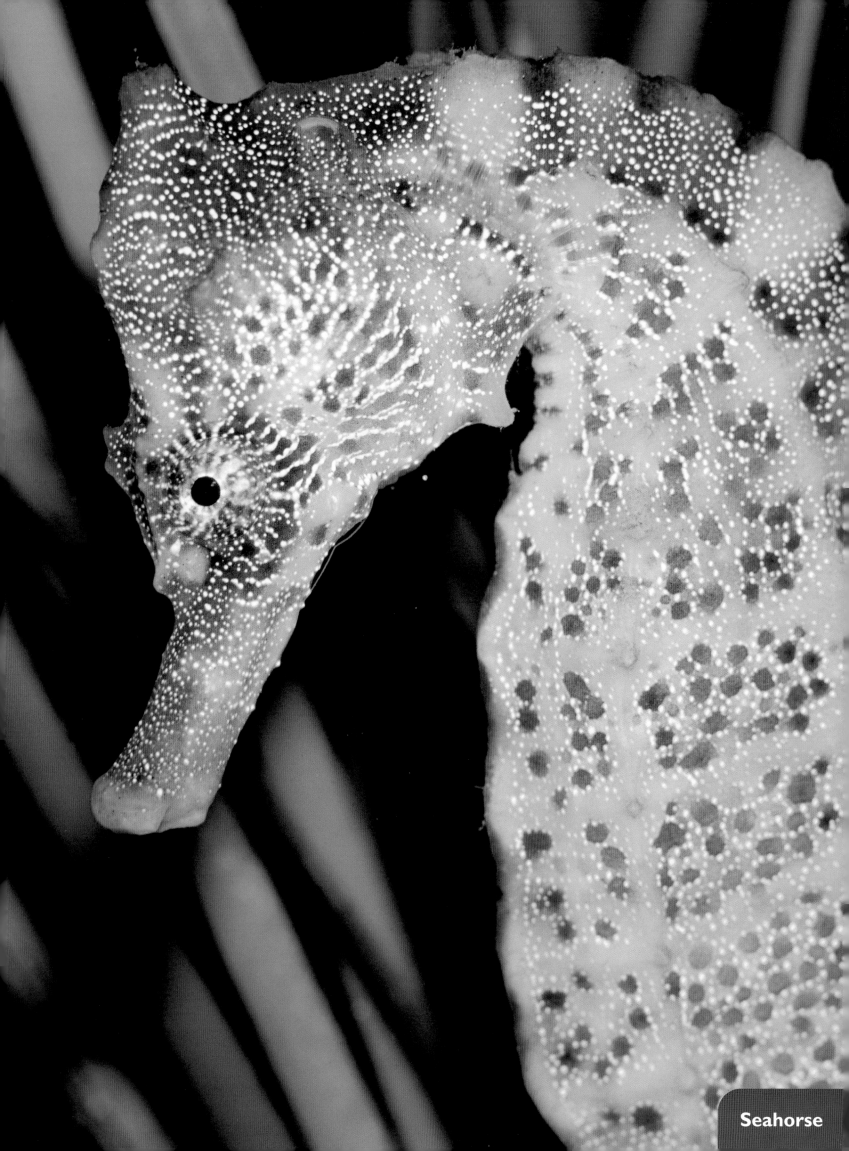

Seahorse

Seahorse

With their long, angular heads, it is easy to see why these animals are called "horses," but you wouldn't be able to ride one. The largest seahorse measures a whopping 10 inches; the smallest, the **pygmy** seahorse, is as big as a fingernail.

Stay-at-Home Dad

In the seahorse world, it is the men who give birth to the babies. The female lays her eggs in a special pocket in the male's belly, called the **brood pouch.** The developing eggs get their food and oxygen from the male. After 2 to 4 weeks, the baby seahorses (which look like miniature versions of their parents) are pushed out of the brood pouch and into the ocean. Some seahorses give birth to as many as 1,500 babies.

Tricky Tail

The seahorse has a flexible tail that it uses to wrap around underwater objects. By grabbing onto a piece of seaweed and staying very still, the seahorse can wait for a meal to swim by without becoming a snack itself. It loves to eat almost any kind of tiny **crustacean** (crus-TAY-shun), a group of shrimplike animals that includes shrimp and crabs. A seahorse's eyes move independently of each other — one eye can look up while the other looks down — so it can scan the water very thoroughly.

How Do They Do That?

When you see a seahorse swimming, you may wonder how it propels itself through the water without seeming to move anything on its body. If you look closely, you'll see tiny, **transparent** (clear) fins on the cheeks and "mane" that flutter at terrific speeds. These tiny fins help the seahorse move and are less obvious to predators than large fins.

photo © Mark Conlin/SeaPics.com • *Under The Sea Poster Book,* Storey Publishing

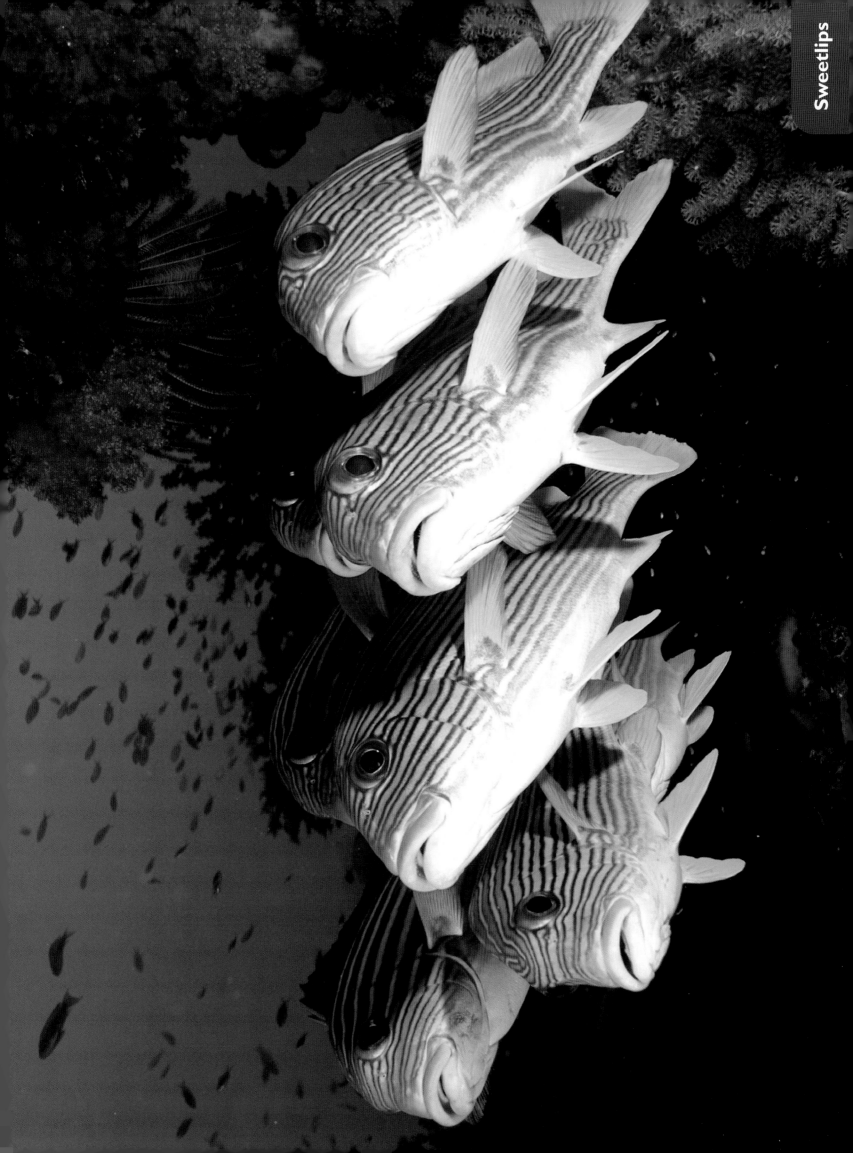

Sweetlips

Sweetlips swim in large packs called **shoals** or **schools.** By sticking close together, sweetlips share safety in numbers from predators such as sharks and other large fish.

This Way and That Way

The sweetlips on the inside of the pack are the safest, but as the shoal swims, each fish changes position. This rapid movement is confusing to would-be predators, making it difficult for them to focus on any one fish. Shoals of sweetlips also find safety on the **reef** (a chain of rocks or coral near the surface of the water) by hiding under overhangs and ledges during the daytime.

School Sense

A line down the sides of sweetlips helps them to sense each other when they are swimming in large groups. This line is called a **lateral line.** Most ocean fish have one. The lateral line enables sweetlips to feel small changes in pressure or underwater waves that occur when other fish swim nearby or when an object is close by. Lateral lines are especially helpful when the water is murky and the sweetlips can't see very well.

Dinnertime!

Sweetlips have a small mouth with large, fleshy lips that they use to pick **crustaceans** (shrimp and crabs) off the reef for a tasty dinner. While they swim in schools during the day for protection, they break from their groups at night and hunt for their next meal by themselves. It's quite safe for sweetlips to be alone at night, when most of their predators are resting.

photo © James D. Watt/SeaPics.com • *Under The Sea Poster Book,* Storey Publishing

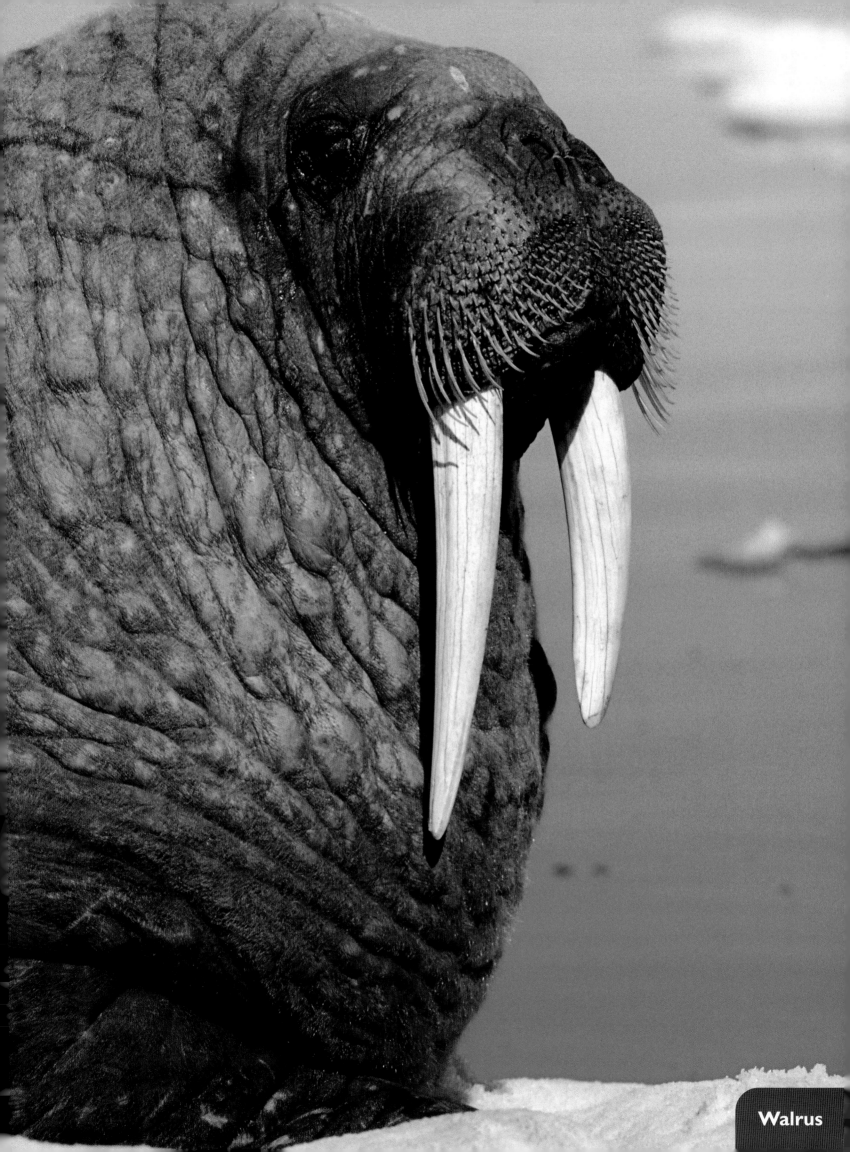

Walrus

Walrus

• • • • • • • • • • • • • •

The first things you may notice when you see a walrus are its huge tusks. Both males and females have tusks, though those of the males are longer. For a long time, people thought the tusks were used to dig for food, but walruses actually use them to do other things: to help climb out of the water onto an ice pack, to fight other walruses for dominance in their group, and to poke breathing holes in the ice when swimming underneath.

Expert Swimmer, Not-So-Expert Walker

When underwater, the walrus is an extremely graceful swimmer and can dive as deep as 300 feet. Walruses can even sleep in the water. By inflating special air sacs in their throat, they can float around on the surface with their head out of the water and take a snooze! When on ice or land, however, they look more like clumsy caterpillars inching and lumbering around using their hind flippers to push them forward. When young walruses get tired of walking or swimming, they have been known to jump onto their mother's back for a free ride. What a good idea!

Size-Wise

Walruses are actually really big seals and, in fact, are the largest seal of all. Adults regularly weigh more than 2,000 pounds and are around 12 feet long. Newborns weigh about 150 pounds and are usually a little less than 4 feet long.

Need a Shave?

Those bristly whiskers that look like a big mustache are actually a valuable survival tool. The whiskers are highly sensitive and help detect food when a walrus dives for a meal. Their **snouts** (noses) contain up to 700 of those big, bristly hairs!

photo © Doc White/SeaPics.com • Under The Sea Poster Book, Storey Publishing

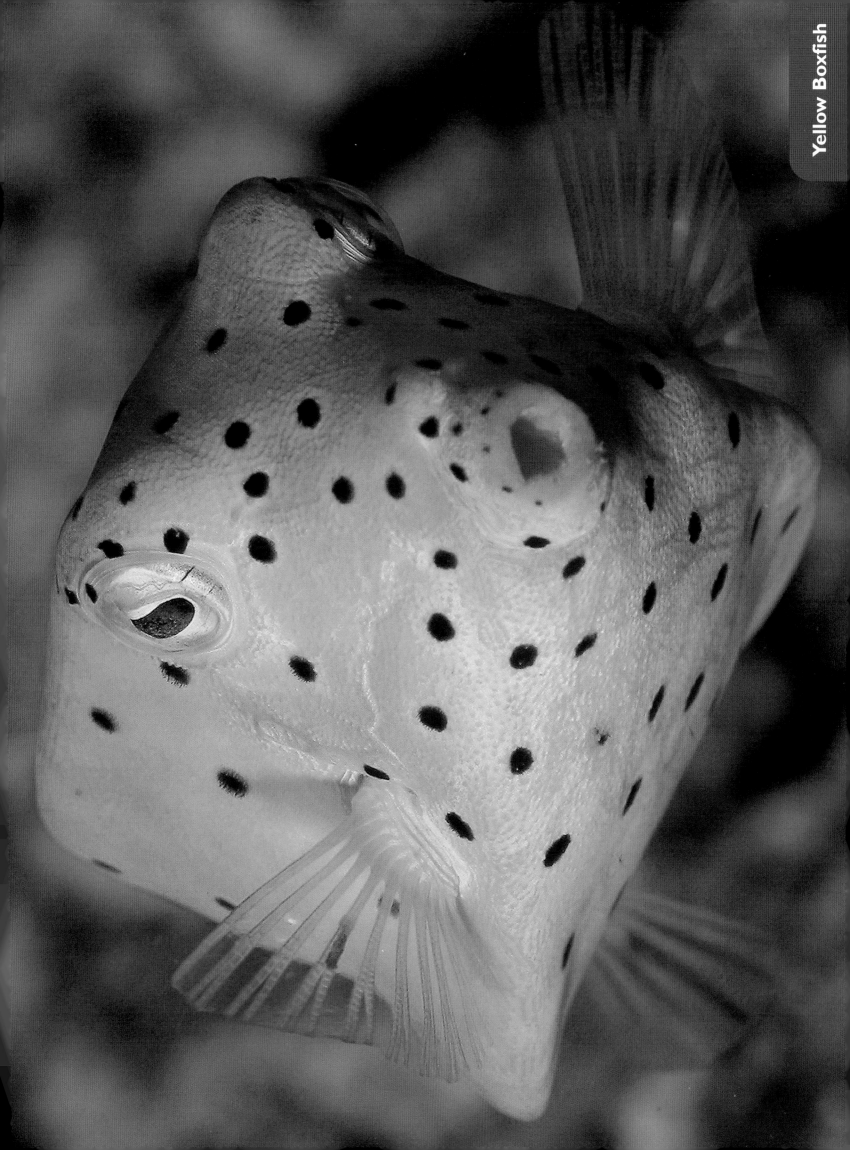

Yellow Boxfish

Yellow boxfish cruise the **coral reef** (a chain of coral near the surface of the water) hunting for sea stars, clams, and shrimp. Because they have a cube-shaped body, they are able to make sharp turns around every corner. When these fish are young, they are bright yellow with large black polka dots. As they get older, their body becomes longer and more slender. The bright yellow turns to a dark brown and the black spots become lighter, sometimes even white.

All in the Family

Yellow boxfish are cousins of trunkfish. These fish have similar bodies. Even though they have different shapes (a trunkfish looks like a triangle when it faces you and a boxfish looks like a square), they are both covered in **hexagonal** (six-sided) bony plates that protect them from predators. The hard plates are **fused** (blended together) to create a tough covering that acts like a suit of armor.

One Strong Cube!

Besides thick skin, yellow boxfish have another defense against predators. They can release a powerful **toxin** (poison) when they feel threatened.

In Demand

Yellow boxfish are often collected from the wild and sold in pet stores for people to keep in home aquariums. When they are taken from the wild, these fish are very small, about the size of a quarter. Divers with nets easily capture them, because yellow boxfish do not have many natural predators and are slow swimmers. Unfortunately, most people who buy these little swimming cubes don't realize that they grow to be quite large (up to 17 inches long!), making them far too big for the average family aquarium.

photo © James D. Watt/SeaPics.com • *Under The Sea Poster Book*, Storey Publishing

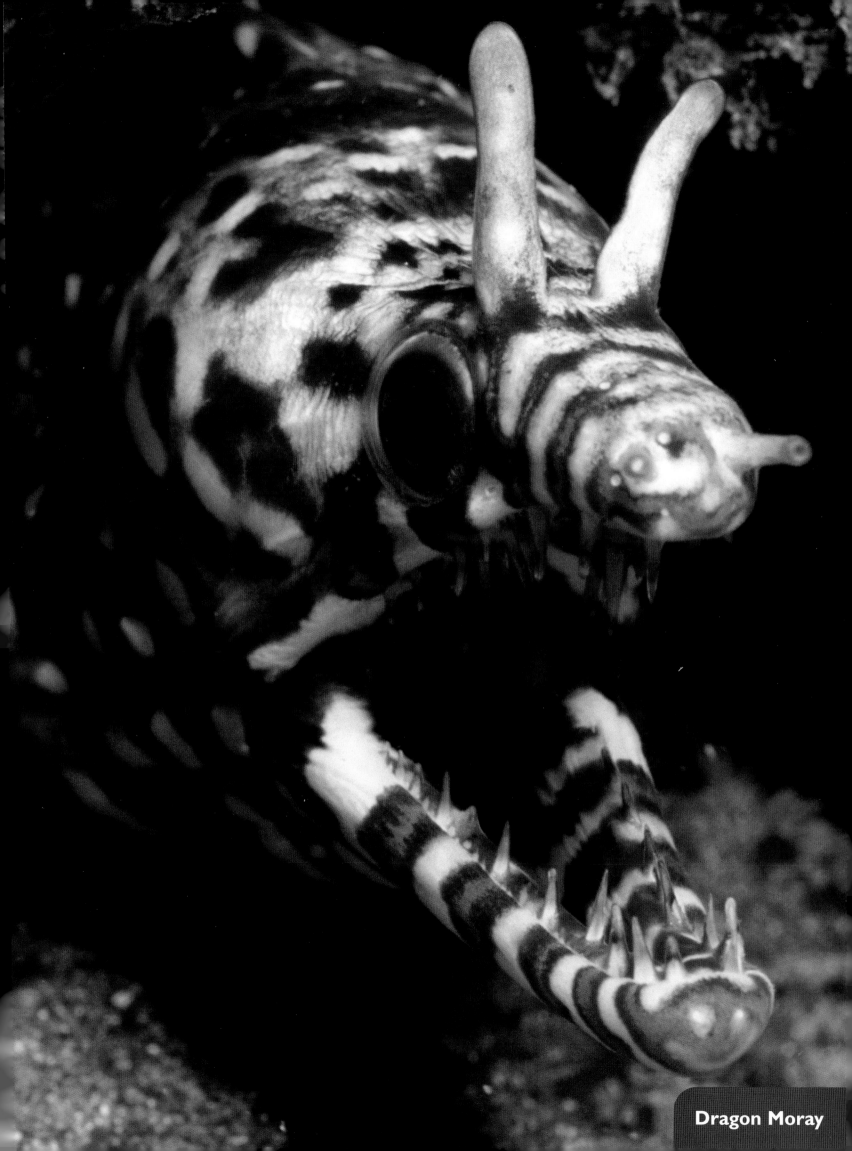

Dragon Moray

Dragon Moray

•

It's not difficult to guess how this moray got its first name, *dragon*. If you look closely at those sharp teeth, that pointy nose, and those glaring eyes, you can see that the only thing missing is fire shooting from its mouth!

Pins and Needles

The moray's teeth are sharp, long, and narrow. That's so it can quickly pierce, grab, and hold small fish, squid, or shrimp that make the mistake of getting too close to a moray's cave. Dragon morays' teeth are also pointed backward, so their prey gets pinned inside of their mouth.

On the Gentler Side

Even though your first impression may make you scared of a dragon moray, most of its dangerous look is just for show. Their toothy mouth must be open for them to breathe, and even though it may open wider if threatened, most of the time an open mouth is harmless. Morays will bite a human, however, if they feel trapped or cornered, or if they think a wiggly finger is food. If you are lucky enough to see a dragon moray while swimming, don't approach it. You'll find dragon morays in small caves in **coral** and **rocky reefs** (chains of coral or rocks close to the surface of the water) around the tropical Pacific Ocean.

How a Dragon Moray "Chews"

After a dragon moray has swallowed its food whole, it does something called **knotting.** It will twist itself into two loops and then stick its head through the loops, making itself into a knot. This helps it digest its food.

photo © Doug Perrine/SeaPics.com • *Under The Sea Poster Book,* Storey Publishing

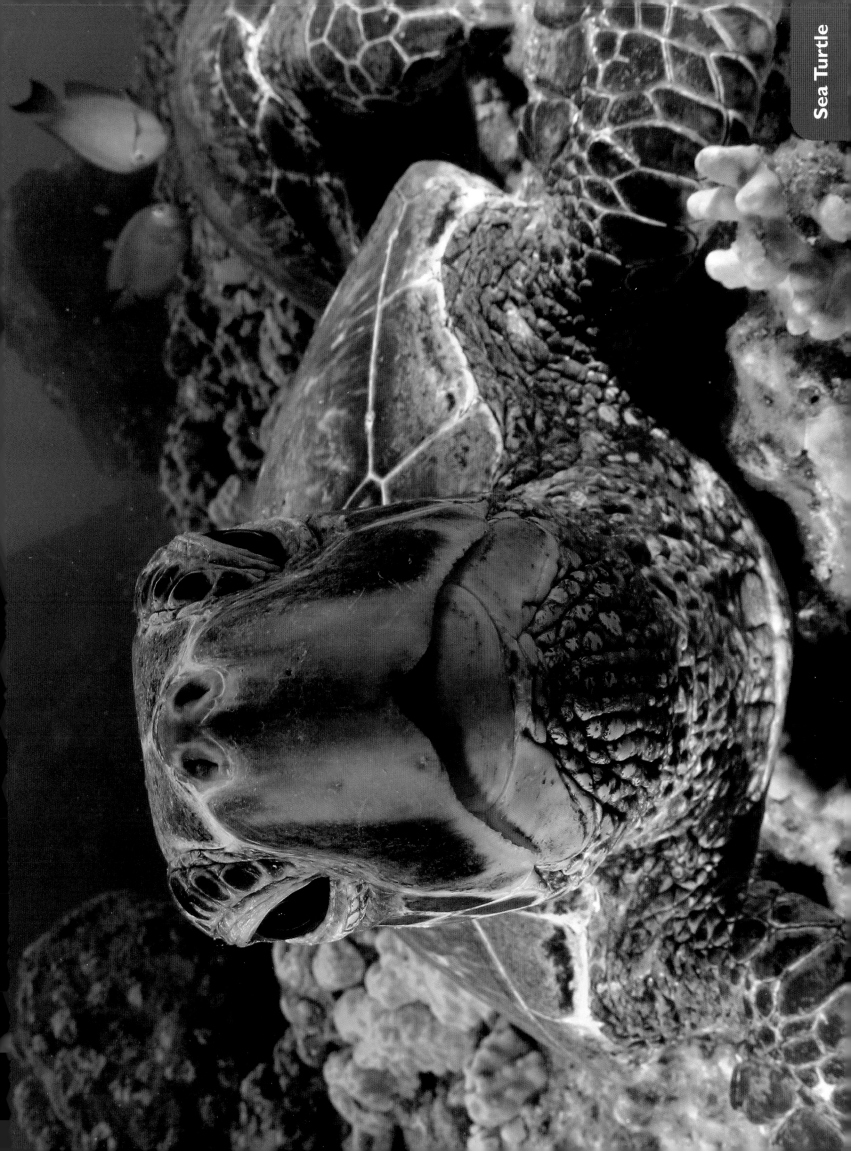

Sea Turtle

This gentle giant of the turtle world spends almost its entire life in the ocean. Sea turtles leave the water only on one occasion: when they lay their eggs. The adult females crawl up on a beach to dig a nest and bury their eggs. The young hatch on land, but after they dig out of the nest, they make a dash down the beach and into the waves.

One Tough Shell

Sea turtles have the strongest armor of all the **vertebrates** (animals with backbones). Their **carapace** (back shell) is covered with bony plates, and their belly is covered with another hard plate, the **plastron.** Unlike their freshwater relatives, however, sea turtles are unable to hide their head in their shell.

See Turtles?

There are eight species of sea turtles, and they can be found in the warm parts of oceans around the world. Still, if you see a sea turtle in the wild, you are very lucky! They spend most of their time traveling, feeding on things like sea grasses and jellyfish, and sleeping underwater. Because turtles belong to the **reptile** group, which includes lizards, snakes, crocodiles, and tortoises, they come to the surface only for a quick breath of air.

Welcome Home

When an adult female builds her nest on a beach, it is typically the very same beach that she was hatched from. Between the time they hatch out of their Ping-Pong-ball-sized eggs (along with 100 to 200 brothers and sisters) and build their own nests, female sea turtles will have roamed the seas for hundreds of miles. Scientists still don't know how they find their way back to the same beach after so many miles and so many years!

photo © James D. Watt/SeaPics.com • *Under The Sea Poster Book*, Storey Publishing

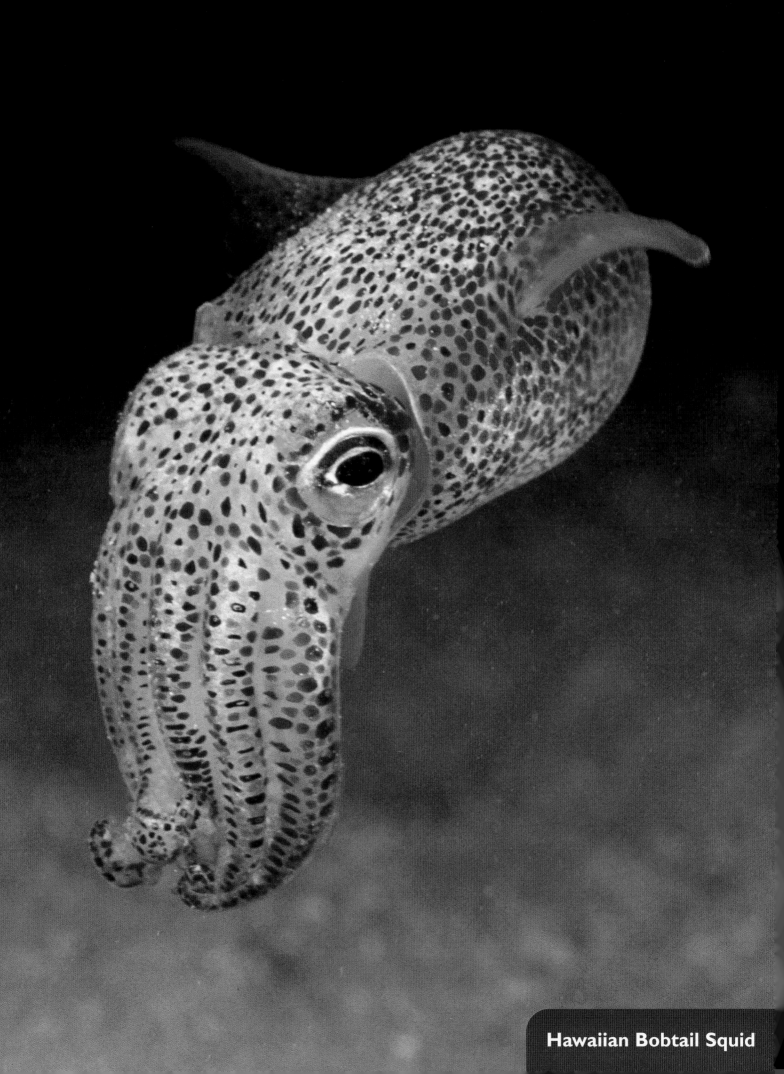

Hawaiian Bobtail Squid

Hawaiian Bobtail Squid

• •

The Hawaiian bobtail squid is small in size. Only 2 to 3 inches in length, it is easily dwarfed by its enormous cousin the giant squid, which can grow up to 60 feet long. This little squid, however, has some tricks that its bigger cousin doesn't have.

Put on the Moon Lights

During the day, the Hawaiian bobtail squid stays hidden in the sand, but during the dark of night it swims up into the water to feed on shrimp. To avoid being seen, it can make its stomach glow with **bioluminescence,** which is similar to the light produced by fireflies. It will make its stomach light look like moonlight so that predators hunting below the squid will not be able to see it. This **nocturnal** (nighttime) behavior helps prevent the squid from becoming a tasty meal.

The Better to See You with, My Dear

Squid have some of the best eyes in the animal kingdom. Not only do they see colors and details better than humans, but studies show that their eyes can also see things that are invisible to us. Because of special filters on their eyes, squid can even find some **transparent** (clear) animals to feed on.

Skilled Swimmers

Squid can move either slowly or quickly, depending on how they swim. The big fins on the side of the squid can wave, allowing it to move slowly through the water with incredible precision and control. This type of swimming uses up very little energy. If the squid needs to move quickly, it pumps seawater out of its body very rapidly and jets away from danger.

photo © Doug Perrine/SeaPics.com • *Under The Sea Poster Book,* Storey Publishing

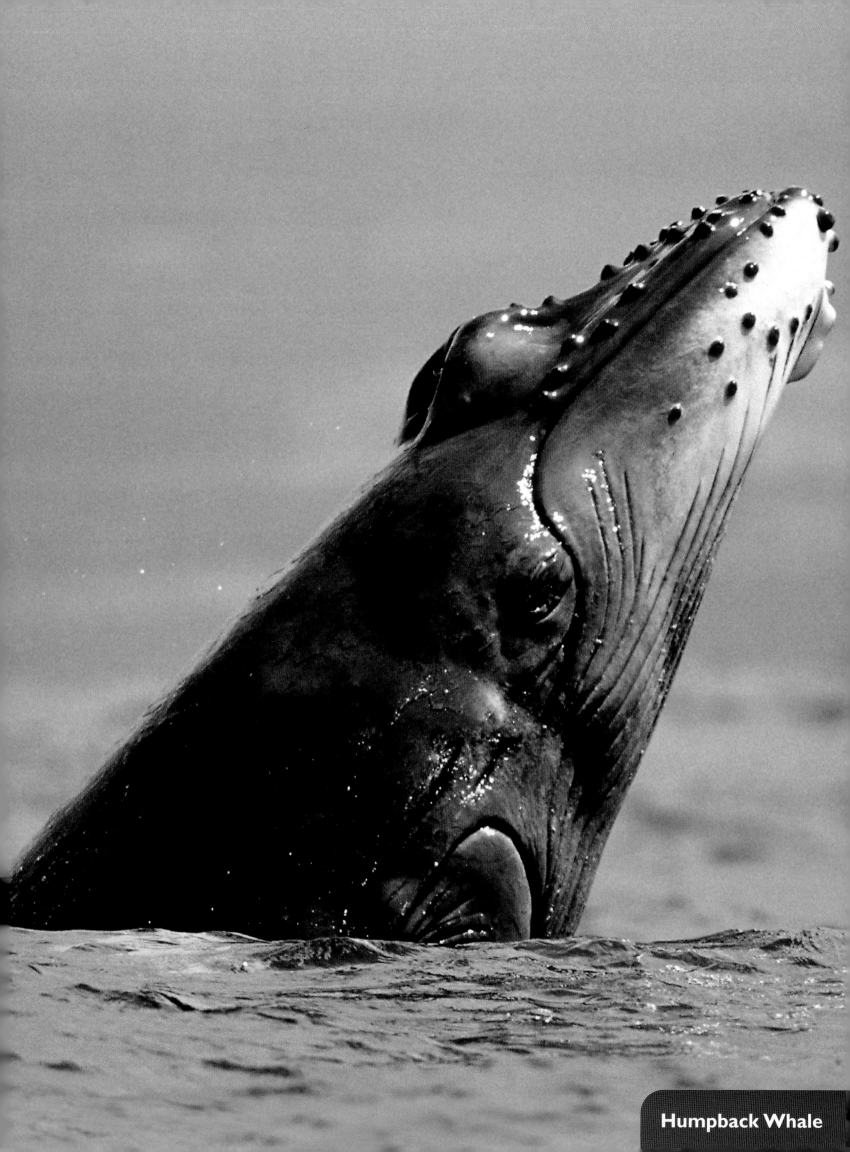

Humpback Whale

Humpback Whale

These whales are probably called humpbacks because of the way they arch their back out of the water when they dive. By looking at this picture, you may wonder why it is not called a "humphead" whale, but those bumps on its head are actually its nostrils (or **blowholes**). Humpbacks grow to be 52 feet long — about the length of a school bus! They roam the oceans in groups called **pods,** which contain anywhere from 2 to 15 whales.

Magnificent Moms

Humpback calves are born tail first and, with the help of their mother, swim to the top of the ocean less than 10 seconds later to take their first breath. Humpback moms take special care of their young ones (which at birth are about the length of a car!) by providing them with protection, swimming lessons, and nourishing milk. The milk is super-rich, containing about 50 percent milk fat. That's more than 20 times the amount of fat in the cow's milk that most people drink.

Going South for the Winter

Humpbacks spend summertime feeding in the food-rich waters of the north. Before the icy winter starts, they swim south to warmer water. They spend wintertime in the cozier ocean temperatures around Hawaii and Mexico and in the South Pacific.

Did You Know?

Humpbacks frequently rise out of the water, as the one in the picture is doing. Nobody knows exactly why they jump, but it may be simply to have fun or show off. If you're ever lucky enough to go on a whale-watching boat, you may see a humpback whale jump out of the water — maybe even surprisingly close to your boat!

photo © Masa Ushioda/SeaPics.com • *Under The Sea Poster Book,* Storey Publishing

Squirrelfish

Squirrelfish hang out around tropical **coral reefs** (chains of coral close to the surface of the water) near the equator. Behind this squirrelfish, you can see a very large brain coral. Everyone can see where the brain coral got its name! The wrinkles on the coral look a lot like the folds in a human brain.

What's in a Name?

So, how did the squirrelfish get its name? It probably got it because in some ways it acts like its **terrestrial** (land-based) namesake. Squirrelfish do a lot of chattering below water, just as squirrels do on land. They produce sound by rubbing together the teeth in their throat and by rubbing special muscles on their **swim bladder** (a gas-filled sac inside the body that keeps them from sinking to the bottom). They make a sound like the kind you make when you rub your fingers on a balloon. Also, squirrelfish move quickly and have large eyes like squirrels.

Night Vision

All squirrelfish have large, bright eyes for an important reason. Because they are **nocturnal** (actively hunt at night), they need good night vision to help locate their favorite foods, such as shrimp and other small **crustaceans** (crabs, for example).

The Better to Hide

Like many deep-ocean dwellers, squirrelfish are red. This helps them blend in with the water because red can't be seen in the dark ocean. Although red is a flashy color under the sun, in the water it looks more like black.

photo © Manfred Bail/SeaPics.com • *Under The Sea Poster Book,* Storey Publishing

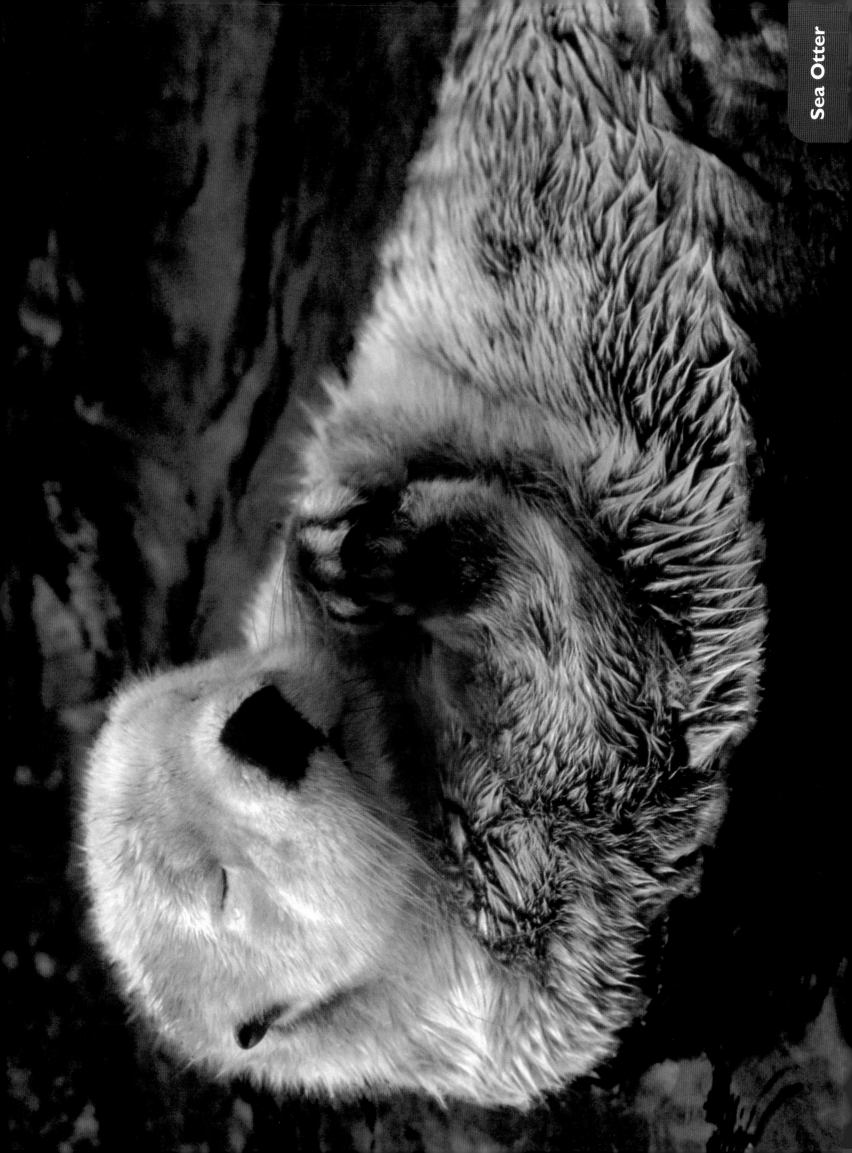

Sea Otter

● ● ● ● ● ● ● ● ● ● ● ● ● ● ● ● ● ●

Sea otters live in cold water and must conserve their energy to keep warm. When not hunting for food, sea otters sleep and try to keep as much of their body out of the water as possible. By keeping their paws and flippers in the air, they stay warmer.

No Blubber?

Unlike whales and seals, sea otters don't have a thick layer of **blubber** (fat) to keep them warm. Instead, they depend on a heavy coat of fur that traps lots of air bubbles, keeping the otter **insulated** (protected) from the cold ocean. One square inch of sea otter fur contains one million hairs (a typical dog has about 60,000 hairs in the same area). In fact, sea otters have the thickest fur in the animal kingdom and were nearly hunted into extinction because people used this soft fur for coats and hats.

Hungry!

Sea otters also stay warm by eating huge amounts of food. Every day a sea otter eats 25 percent of its body weight. For a 100-pound human, this would mean eating 100 quarter-pound hamburgers a day!

Armpit Tool

Sea otters eat hard-shelled animals like clams, mussels, sea urchins, and abalones. Although sea otters' teeth are sharp, they are not sharp enough to open these tough-to-eat foods. Instead, the sea otter keeps a rock in a special pouch under one of its armpits. When an otter comes to the surface, it rests on its back, takes out the rock, and uses it to smash open its meal. Some sea otters have even been seen using old soda bottles to help crack open their food!

photo © Kevin Schafer/SeaPics.com • *Under The Sea Poster Book,* Storey Publishing

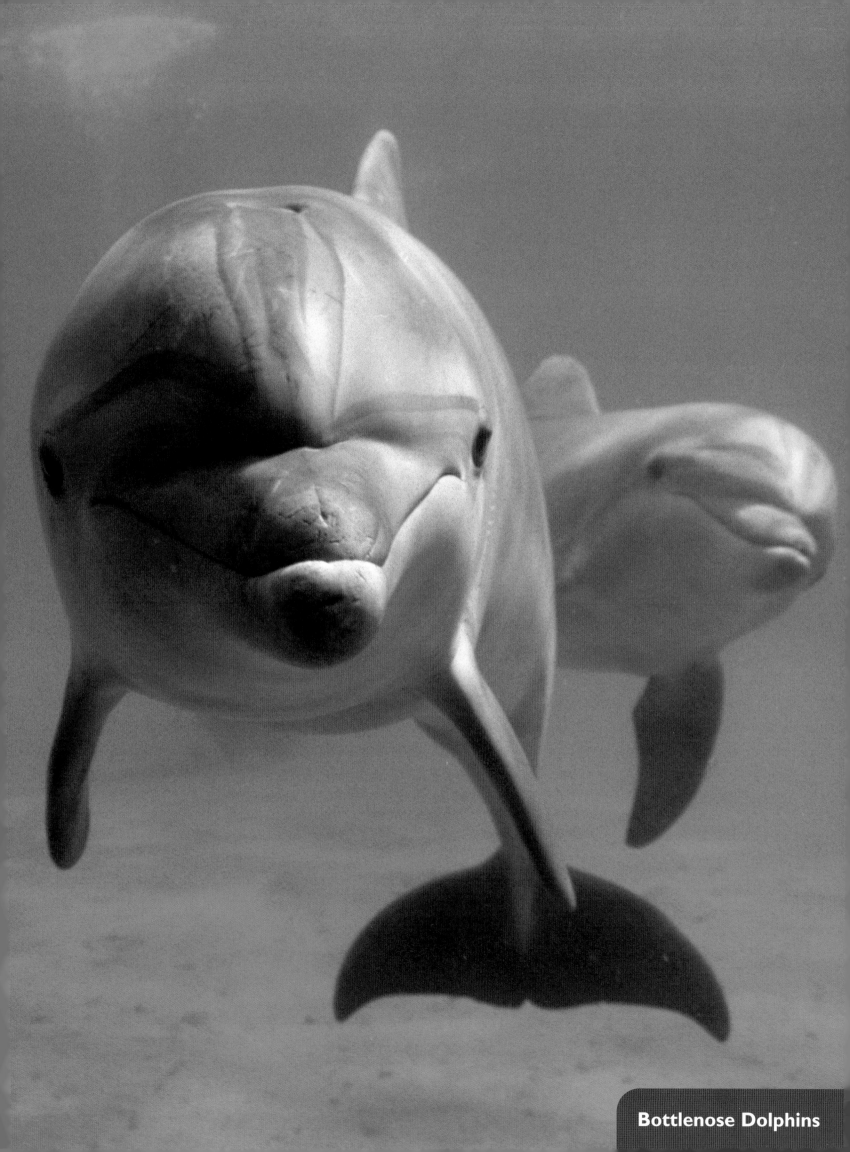

Bottlenose Dolphins

Bottlenose Dolphins

With a little imagination, it may look as if the dolphins in the picture are greeting you with a polite "Nice to meet you!". In fact, scientists believe that dolphins have incredibly complex language systems. Some scientists even think there is a good chance that humans will someday be able to have long, meaningful conversations with dolphins.

Speaking of Speaking

Dolphins have a language all their own. They speak, or **vocalize,** by creating a variety of clicks and whistles. What sounds like a secret code to us could be a dolphin telling other dolphins "Hey, guys, come over here, I found a **school** (group) of tasty fish," or "Look out!".

Mealtime

Adult dolphins can weigh more than 500 pounds and eat up to 30 pounds of food each day. They aren't picky about what kind of sea life they eat, but fish, squid, and shrimp are their favorites. If they need to, they can **stun** (temporarily paralyze) their underwater prey with the same tools they use to communicate — loud clicks and short bursts of sound. Sometimes dolphins hunt in groups so they can herd schools of fish and catch them more effectively.

Brainiacs with Teeth

The brain of the bottlenose dolphin is larger than our human brain! Also, that smiley mouth located on that long **snout** (nose) is loaded with 100 or so sharp teeth, each about $\frac{1}{2}$ inch long.

photo © Ingrid Visser/SeaPics.com • *Under The Sea Poster Book,* Storey Publishing

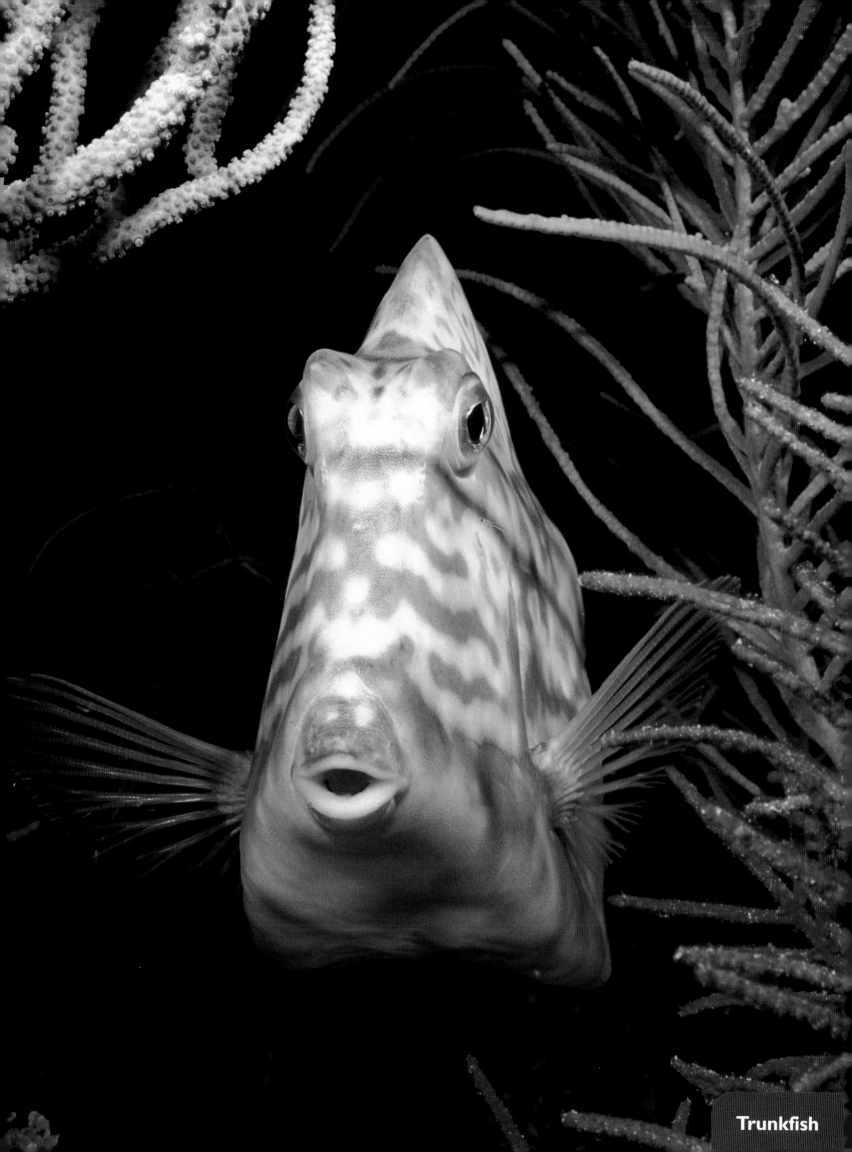

Trunkfish

Trunkfish

· · · · · · · · · · · · · · · ·

The odd-looking, triangle-shaped body of this trunkfish is covered with **hexagonal** (six-sided) bony plates. The plates are held firmly together and act as a suit of armor for these slow-swimming fish.

Unique Swimming Style

Because of their hexagonal plates, the trunkfish style of swimming is different from that of most other fish. Their fins stick out through this protective barrier, like oars on a rowboat, to move them along. These "oars" allow trunkfish to steer themselves in and around **coral reefs** (chains of coral near the surface of the water) and sea grass beds, where they spend most of their time.

Not a Tasty Bite

Since trunkfish are not quick swimmers, you'd think they'd be an easy target for predators in search of a meal. Their bony plates, however, are a good shield, and when they feel threatened, they can secrete a powerful **toxin** (poison) into the water that is strong enough to kill an enemy. Because trunkfish have such good methods of defense, they do not seek safety in numbers and typically spend much of their time alone, on the lookout for the next meal.

What's for Dinner?

Trunkfish are not picky eaters. They continuously hunt for food on the coral reef. Their favorite meals are **benthic animals** (those that live on the bottom of the ocean) such as small clams, worms, crabs, shrimp, and sponges. Trunkfish eat their vegetables and will often make a meal of **algae** (small, plantlike organisms) and sea grass.

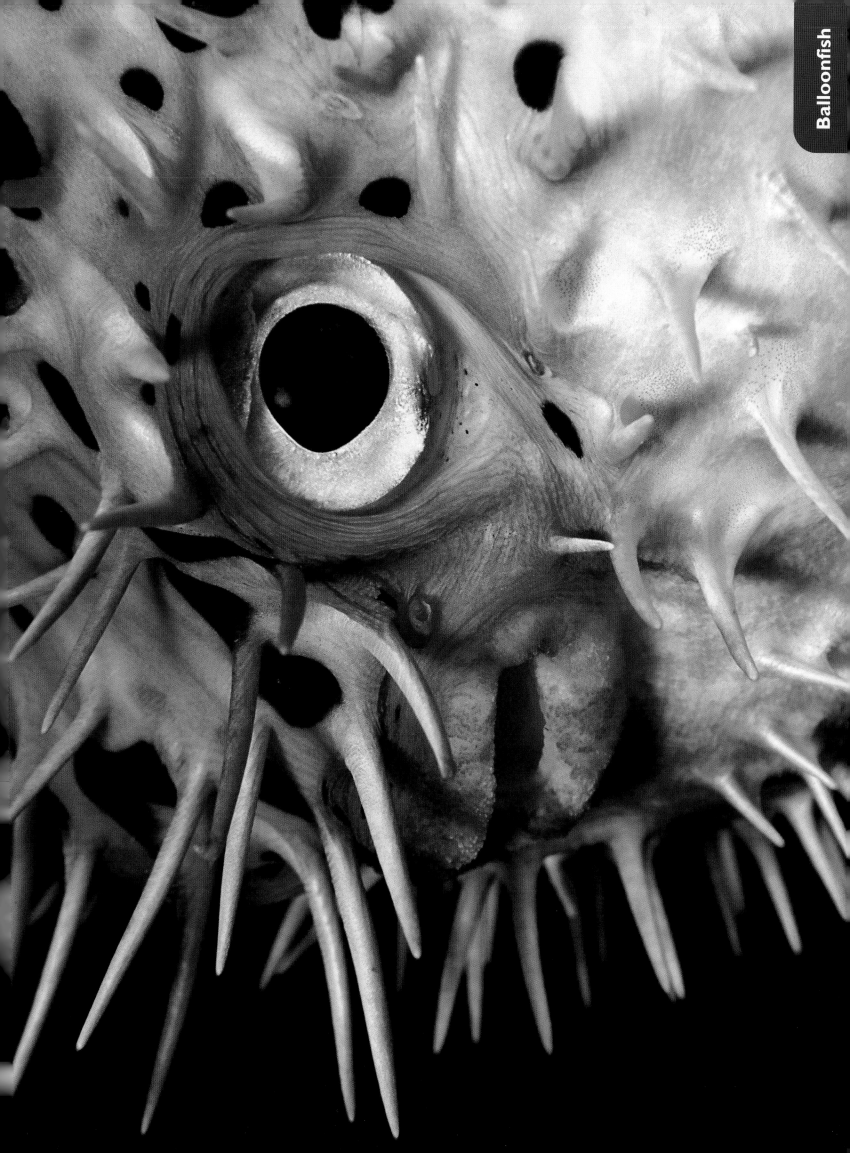

Balloonfish

Balloonfish are prickly characters. Like porcupines, their bodies are covered in sharp spines. So, it's no wonder that balloonfish are also called porcupine fish.

Sharp or Smooth?

When the balloonfish is swimming normally and feeling comfortable, its spines lie flat. But when it is bothered or feels threatened, the balloonfish can suck water into its body and inflate itself just like a water balloon. This causes all of the spines to stick straight up and the fish resembles a pincushion, making it look unappealing to predators.

Where Do They Live?

Balloonfish are found in tropical waters all over the world. Young balloonfish spend the first part of their lives swimming in the open ocean. When they grow up, they move closer to shore and live around **coral reefs** (chains of coral near the surface of the water), **mangroves** (tropical trees and shrubs), and sea grass beds. They usually swim close to the bottom and stay in shallow water that is less than 35 feet deep. Some sharks are the only predators tough enough to eat an adult balloonfish. Humans are the only other creatures that harm them by catching them with nets, drying their bodies, inflating them, and selling them in tourist shops.

Nighttime Snacks

Balloonfish usually hide among the corals on the reef during the day. At night they come out to look for their next meal. Because they are active at night, balloonfish are **nocturnal** (nighttime) predators. They enjoy dining on hermit crabs, snails, and sea urchins. Balloonfish have strong teeth, almost like a bird's beak, which they use to crack the shells.

photo © Masa Ushioda/SeaPics.com • *Under The Sea Poster Book*, Storey Publishing

Pelagic Jellyfish

Pelagic (pe-LA-jic), meaning open ocean, jellyfish, with their many stinging tentacles, make a safe haven for fish that are good enough swimmers to stay close to one without touching it. These striped fish in the picture have found protection with this jellyfish.

Ouch!

Jellyfish have special stinging cells called **nematocysts** (ne-MA-ta-sists), which are used both for catching food and for defense. Each stinging cell has a tiny, hollow harpoon coiled inside. When the harpoon is fired, it flies out and sticks into the food or predator. Then poison is pumped through the hollow harpoon to kill the prey. Some jellies won't sting people because the harpoon is so short that it can't go very far into the skin. Other jellies cause a painful rash, much like poison ivy, when they sting people. Still others, like the sea wasp of Australia, can kill someone by using even a small number of nematocysts.

Spicy!

With all those stinging cells you would think that nothing would want to eat a jellyfish. However, many animals, such as some types of sea turtles, feed mainly on these squishy creatures. Be sure to keep your plastic bags out of the ocean because sea turtles sometime mistake them for jellyfish and become very sick.

Not Bad for Being Brainless

Pelagic jellyfish are able to do complicated things — swim, catch food, protect themselves, and reproduce, for example — with a very simple body. Jellyfish have no brain, heart, true eyes, or any of the other organs humans find so useful, yet they have been successful in the world's oceans for a very, very long time. The oldest jellyfish fossil ever found was 670 million years old.

photo © Mike Severns/SeaPics.com • *Under The Sea Poster Book,* Storey Publishing

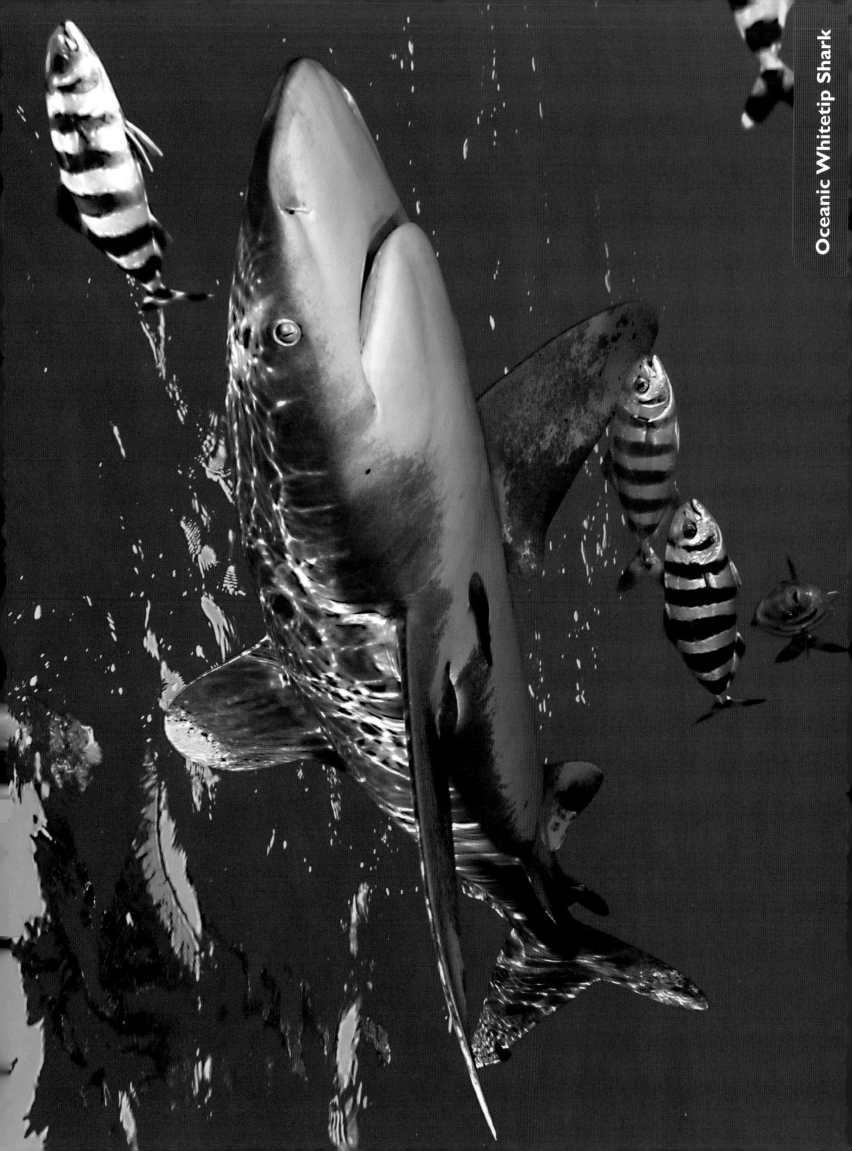

Oceanic Whitetip Shark

The oceanic whitetip shark gets its name from the white marks on its large **pectoral** (side) and **dorsal** (top) fins. Because it swims in the open ocean, where there are few places to hide, smaller fish that are seeking protection from other fish often follow it. In the picture, the whitetip is providing protection to striped pilotfish that also wait to feed on scraps from its meals.

Look Out!

Most sharks in the world's oceans pose no danger to humans. In fact, falling coconuts kill more people worldwide than do shark attacks. The oceanic whitetip, however, is one of the species of sharks considered dangerous to humans. Lucky for us, these animals usually live far from shore and therefore rarely encounter people. Their normal diet is fish, stingrays, sea turtles, seabirds, squid, **crustaceans** (a group of animals that includes shrimp and crabs), and dead mammals.

Shocking Senses

Sharks have special organs called **ampullae of Lorenzini** (am-POO-lay of lor-en-ZEE-nee) on their head to help them find food. These organs are able to detect weak electric currents (as small as half a billionth of a volt) made by an animal's heart and other muscles. Even if an animal is buried in sand, the shark can discover it using these special organs.

Rough to the Touch

Although this shark's skin looks smooth, it wouldn't feel that way if you were to pat it. **Dermal denticles,** tiny toothlike scales, give it a sand-papery texture. In fact, carpenters once used sharkskin as sandpaper.

photo © James D. Watt/SeaPics.com • *Under The Sea Poster Book,* Storey Publishing

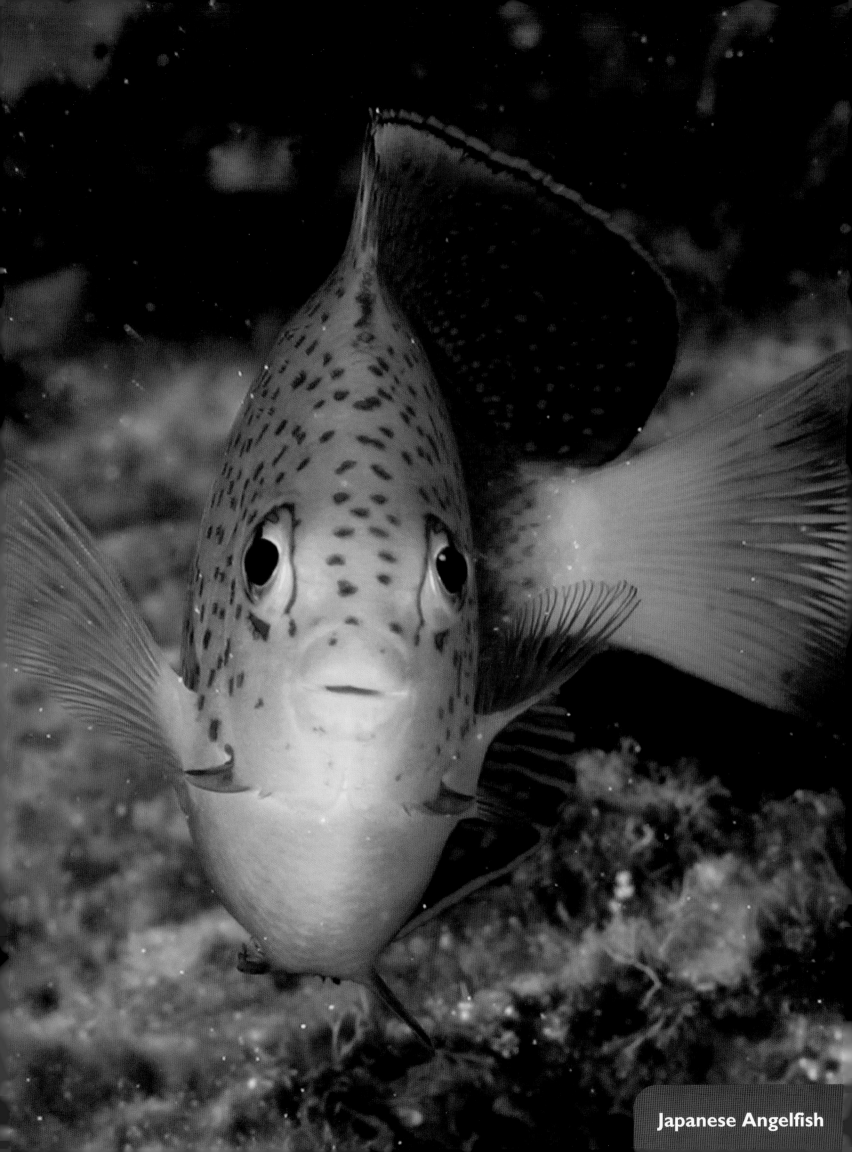

Japanese Angelfish

Japanese Angelfish

Japanese angelfish are small and very attractive inhabitants of the **coral reef** (a chain of coral near the surface of the water). As the name suggests, these fish are found off the coast of Japan. They make their home around the Hawaiian Islands as well, also on rocky and coral reefs. The Japanese angelfish's body is bright orange with striking patterns of blue spots and grows up to 6 inches long.

Good Eaters

Japanese angelfish have a varied diet, though they prefer to nibble on **algae** (plantlike organisms) and plants growing on the reef. They will also feed on **benthic animals** (those living on the bottom of the ocean) such as sea squirts and sponges. Japanese angelfish are sometimes available in pet stores for home aquariums. They do best in a tank when offered a variety of food, including vegetables, in particular broccoli and lettuce.

Feisty Fighters

The small size of Japanese angelfish is not a measure of their attitude. When they set up home on the reef, they guard their territory by chasing off potential intruders. These unwelcome visitors are much larger than the angelfish, but they're not as quick or as brave. Japanese angelfish will also chase away their own kind, especially males.

Switching Roles

If there are no male Japanese angelfish in an area, the strongest female actually changes into a male! She (now a he) can then fertilize female fish.

photo © James D. Watt/SeaPics.com • *Under The Sea Poster Book*, Storey Publishing

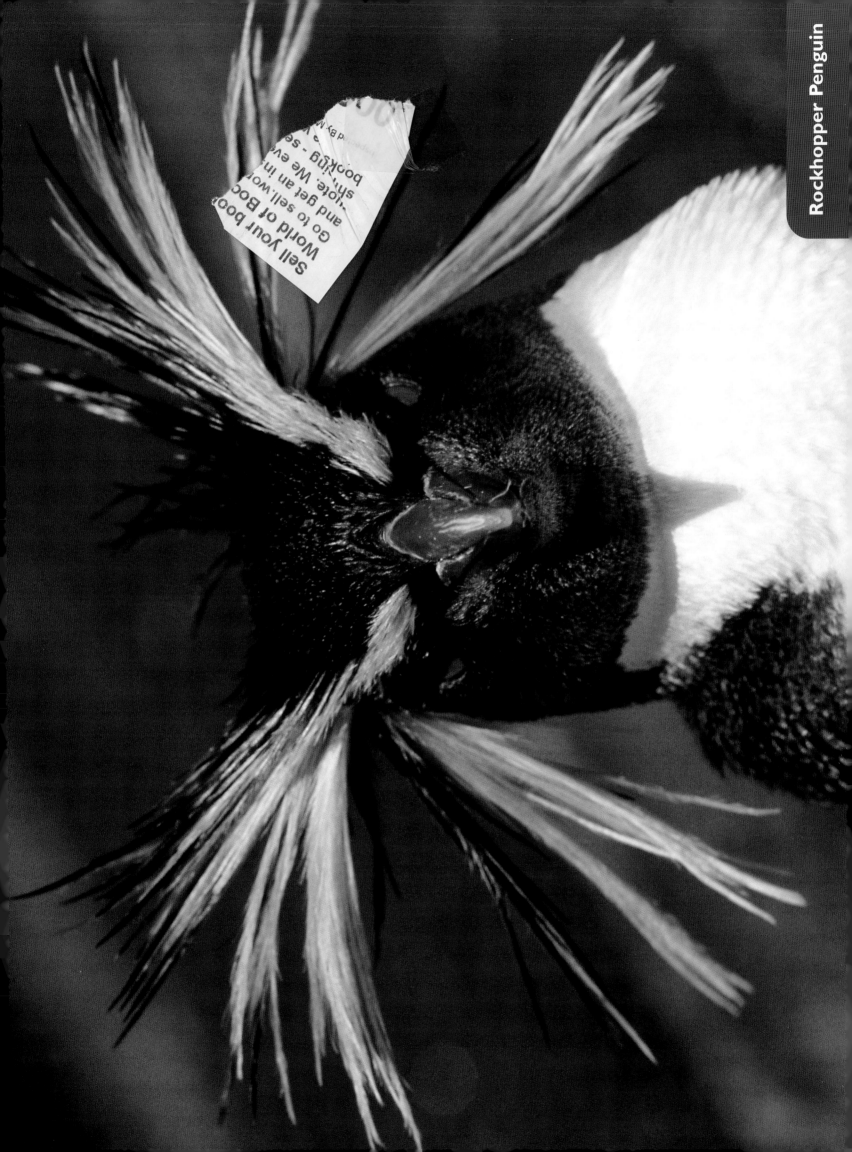

Rockhopper Penguin

You may think the penguin in the picture looks more like a "rock star" than a rockhopper, but don't let appearances fool you. The only music this bird can make is its **vocalization** (a noise that is used for communication) as it jumps from rock to rock. In this case, the music consists of loud squawking.

Speaking of Squawking

What may sound like simple squawks to us are actually very useful in the penguin's world. When penguins pair vocalizations with different body postures, they can tell the neighbors in their **colony** (group) to "stay away from me," or "be my friend," or other important penguin statements.

Expert Fliers

Penguins are masters of flight . . . underwater flight, that is! They cannot fly in the air at all — they can only waddle and hop on land — but once they jump into the water, they become super swimmers. They use the same wings that air-flying birds use, but theirs are made to use underwater (their feet help with some kicking and steering, too).

Why Swim?

Penguins swim to catch food. A rockhopper's favorite menu consists of **krill** and squid (krill are shrimplike animals about the size of a cricket). During nesting season, the male penguin does all the **incubating** (sitting on eggs) while the female hunts for food. If the female rockhopper does not return with food for the nest-tending male, he can produce **penguin's milk** by "throwing up" food he has swallowed for the hatchling to eat. That may sound gross to us, but it's a warm, tasty meal to a baby penguin!

photo © Ingrid Visser/SeaPics.com • *Under The Sea Poster Book*, Storey Publishing

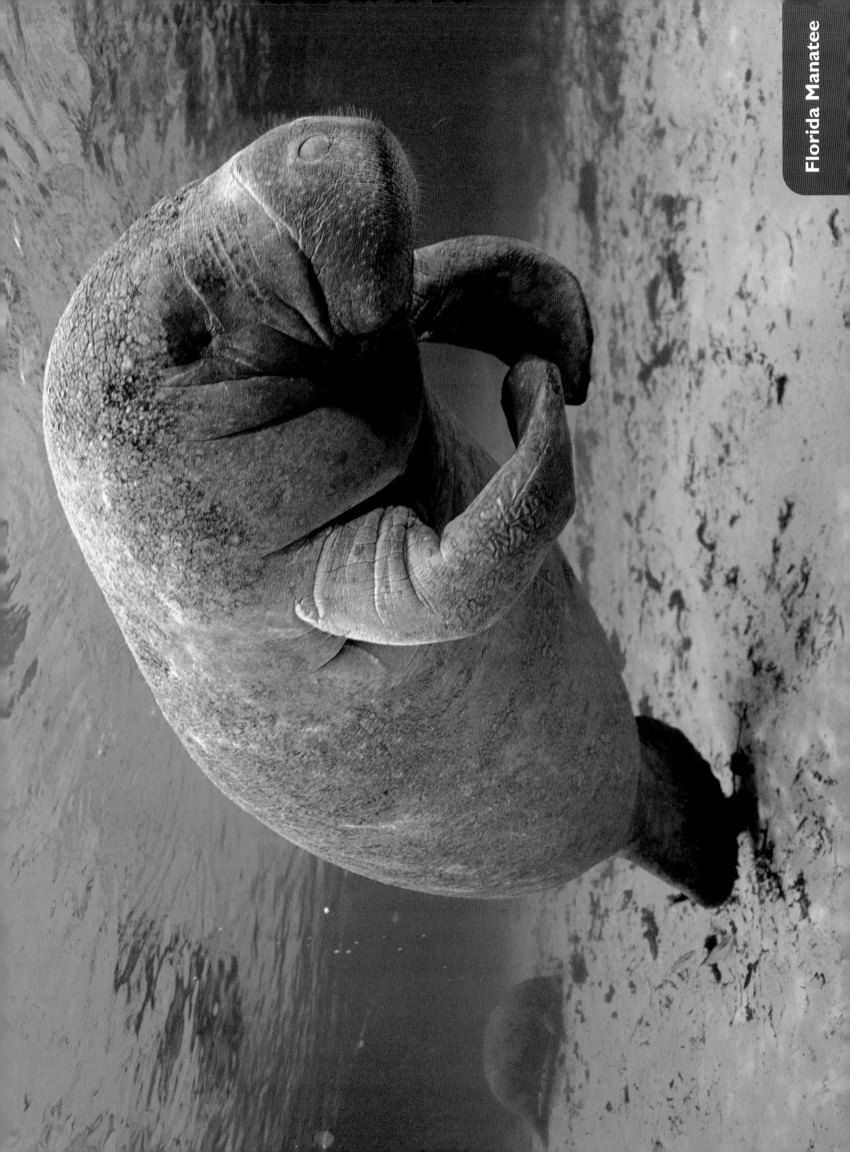

Florida Manatee

· ·

Five species of manatee inhabit the Earth, and they all live in warm, tropical areas along coasts and sometimes far upstream in rivers. The one in the picture is the Florida manatee.

An Icon

Although all five types of manatee are fascinating and special, the Florida manatee has been an ambassador for ocean protection and education for more than 110 years! Back in 1893, people in Florida passed the first law making it illegal to harm a manatee. Since then, the Florida manatee has become famous as a symbol for keeping the oceans healthy.

Gentle Giants

On an average day, a manatee follows a busy schedule of eating and sleeping, interrupted by an occasional slow swim to a new area, where it then does some more eating and sleeping. Manatees are **herbivores,** which means they eat only plants. They eat a lot of plants, however — up to 100 pounds of plants a day! They graze for plants underwater or reach up to nibble plants that grow close enough for them to reach with their big **snout** (nose). These harmless giants can grow to 10 feet long and reach 1,000 pounds! It makes sense that one of their nicknames is "sea cow," doesn't it?

Sea Cow Trivia

Manatees can hold their breath for 15 minutes at a time (do not try this at home!). While swimming, they can only reach a speed of 3 to 5 miles an hour (that's about how fast we're going when we walk quickly). Manatees belong to a group called **sirenians;** ancient people thought they looked like Sirens, a type of singing mermaid in Greek mythology.

photo © Doug Perrine/SeaPics.com • *Under The Sea Poster Book,* Storey Publishing

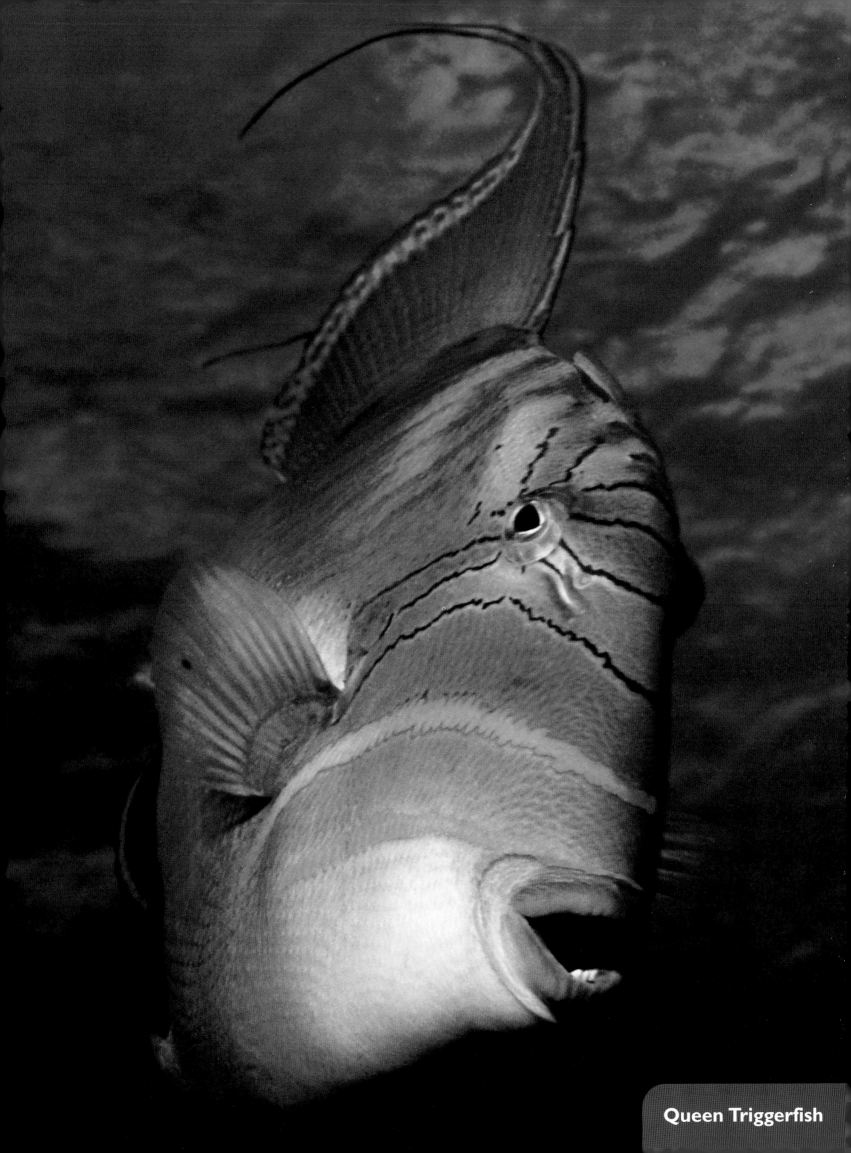

Queen Triggerfish

Queen Triggerfish

• •

The queen triggerfish is one of the most spectacular fish on the **reef** (a chain of rocks and coral near the surface of the water). It has a greenish blue body and fluorescent blue bands on its head and fins. The queen trigger is an eye-catching fish, with its almost egg-shaped body and a large **caudal** (tail) fin. This fish appears to move through the water almost effortlessly, using its **dorsal** (back) fin and **anal** (underside) fin to push itself through the water.

Strong "Triggers"

There are many types of triggerfish in the world's oceans. They all have things in common, one being a "trigger." This trigger is a very thick, strong spine that normally hides in a groove on their back. When the triggerfish feels threatened, however, it will swim deep into a **crevice** (narrow opening) in the reef and lock this triggerlike spine straight up, wedging itself in place. In this position, it is nearly impossible to dislodge a triggerfish from its safe hiding spot.

A Tasty Treat

Queen triggerfish like many types of food, but there is one thing they really prefer — sea urchins! Sea urchins are prickly **invertebrates** (lacking a backbone) related to sea stars. Their long, pointy spines make them difficult for most fish to eat. But, the queen triggerfish blasts a powerful jet of water out of its mouth that flips over the unsuspecting sea urchin, exposing its vulnerable underside. The queen triggerfish then makes a meal of the upside-down sea urchin.

One Bold Fish

Queen triggerfish show very little fear of other animals, including SCUBA divers — especially when the fish set up their territories during breeding season. Many SCUBA divers have received a nasty bite from a queen triggerfish guarding her home.

photo © Doug Perrine/SeaPics.com • *Under The Sea Poster Book*, Storey Publishing

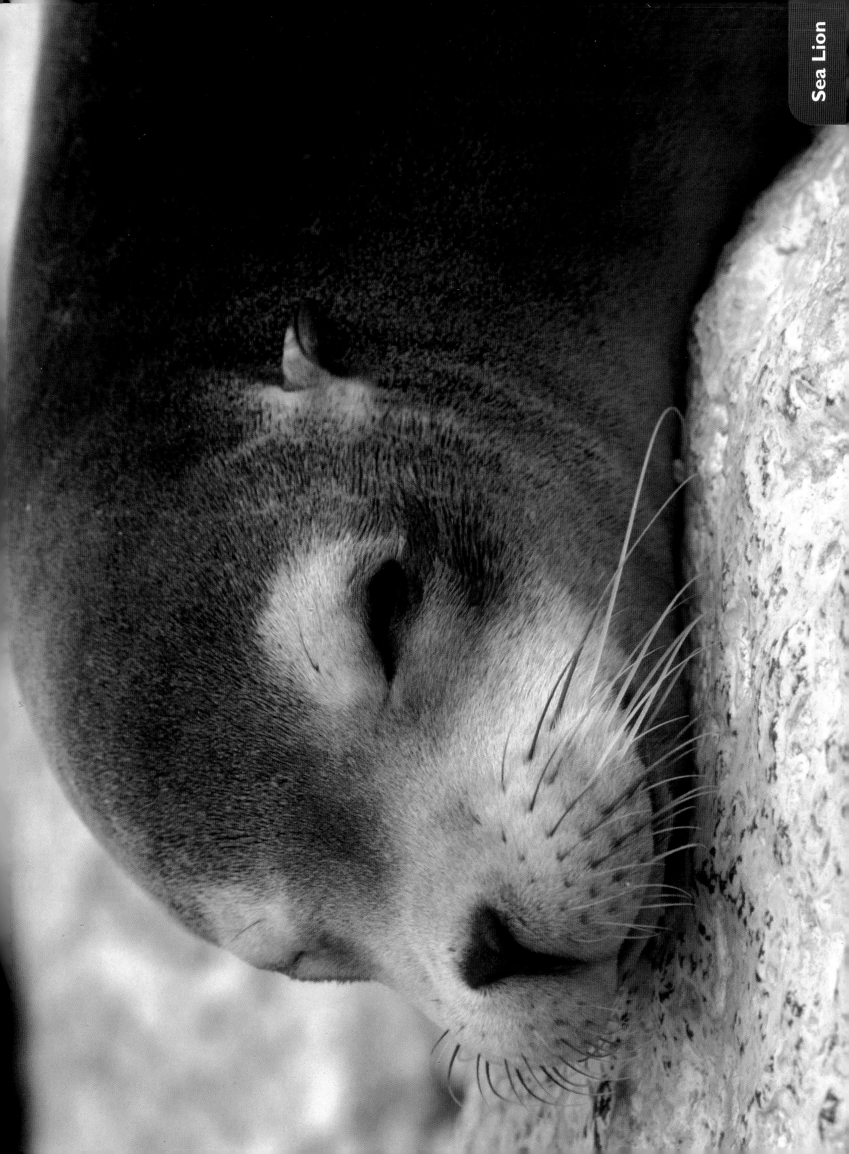

Sea Lion

The lazy-looking animal in the picture is not as laid-back as it may appear. Sea lions spend a lot of time diving for food, playing, and traveling. The next time you see a picture of sea lions resting on some rocks or a beach, remember that they are simply taking a much-deserved break. They also use rest time to bask in the sun and warm up after swimming in the chilly ocean.

Family Traits

There are several types of sea lions, and they can be found from North and South America to Australia and Asia. Some members of the sea lion family have an external ear; some members don't. Sea lions are a diverse family just like people, but sea lions share some things in common. Just like humans have fingers, toes, and a nose, sea lions all have a long, flexible neck and a thin layer of little hairs on their body, and they all swim by paddling with their front flippers and steering with their back flippers.

By Sea and by Land

Sea lions are artful swimmers. They can maneuver quickly underwater, dive down to 600 feet, and shoot up through the surface of the water and leap through the air. When on land, they are not quite as graceful, but they still manage to get around pretty well. Those same front flippers that they use to paddle underwater can be turned forward to walk. You can mimic their walk by lying on the floor and pulling yourself forward by "walking" on the palms of your hands. Give it a try!

The Sea Lion's Secret

If you see a sea lion that has been taught to balance a ball on its nose, this is a trick! It "magically" supports the ball by turning its thick whiskers forward, which is difficult to see at a distance, so you don't notice it.

photo © David Shen/SeaPics.com • *Under The Sea Poster Book,* Storey Publishing

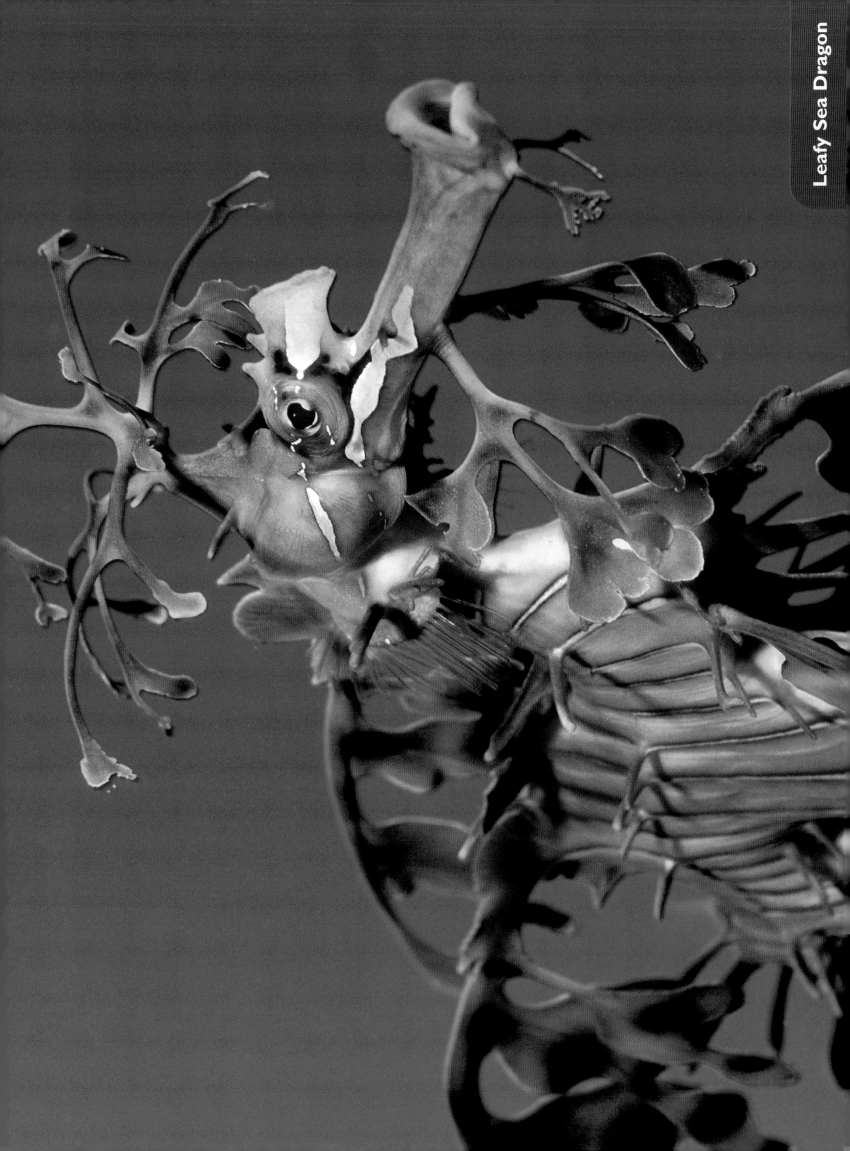

Leafy Sea Dragon

When you see a leafy sea dragon for the first time, you wonder if it's an animal at all. With frilly fins and plantlike coloring, the sea dragon looks more like a piece of seaweed than a fish. This amazing **camouflage** (blending in) is what helps keep the sea dragon safe in the kelp forests of the Australian seas.

Vacuum Cleaners

The sea dragon belongs to a group of animals that includes seahorses, pipehorses, and pipefish. They all have a similar-looking tube-shaped nose and mouth. The long, delicate mouth of the leafy sea dragon is used to pick tiny, shrimplike animals from the water. To make sure these animals don't escape, the tip of the mouth can open very quickly, creating an incredibly strong current. One moment a small shrimp is floating by and the next — zip! — it's in the sea dragon's mouth. Each day the sea dragon may eat thousands of these shrimplike animals.

Tail Babies

Unlike seahorses, male sea dragons raise their young on their tail rather than in a special pouch on their belly. They have hundreds of tiny pits along the tail, each holding one egg. The eggs stay on the tail for 4 weeks and then hatch.

One-of-a-Kind Faces

Each and every sea dragon has a unique face. Researchers are using this fact to help identify individual sea dragons and learn more about them. Already they have discovered that sea dragons have a good navigation system and will swim up to 300 yards — the length of three football fields — from their home base in search of food but always return to the exact same spot.

photo © James D. Watt/SeaPics.com • *Under The Sea Poster Book*, Storey Publishing

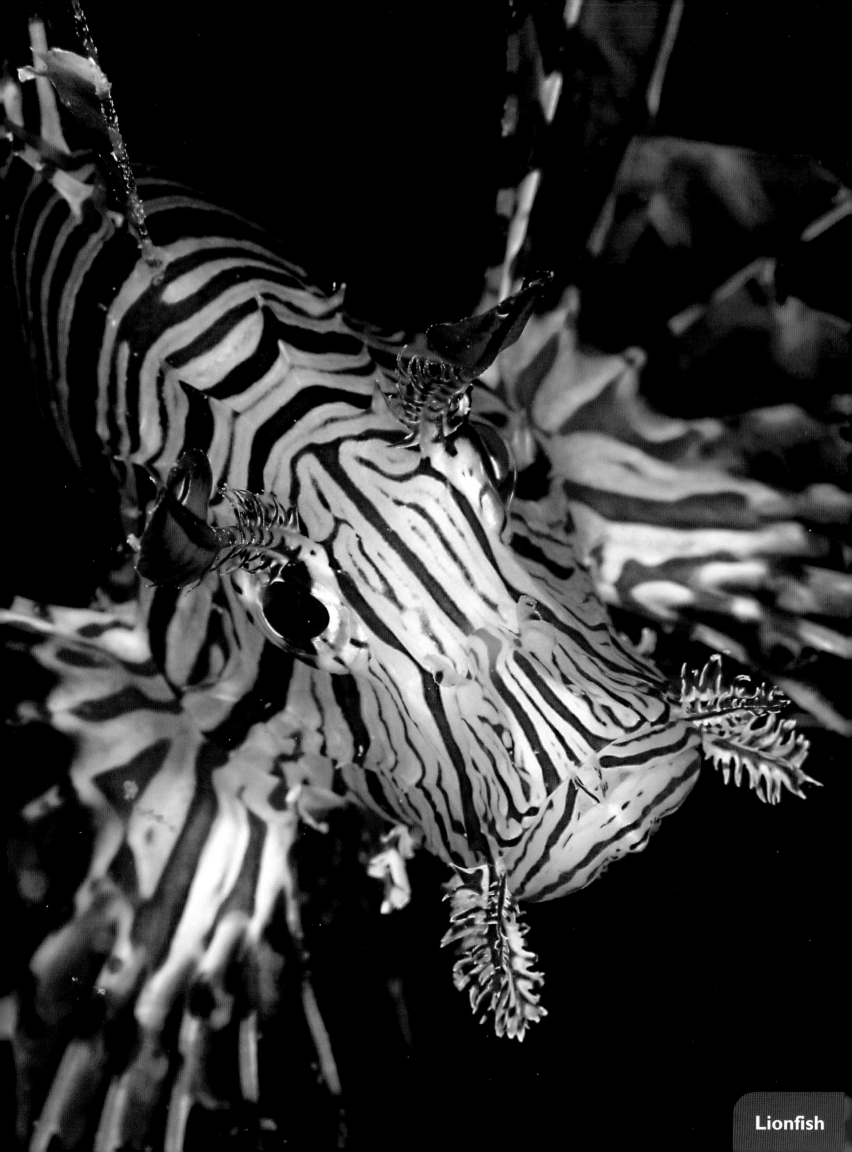

Lionfish

Lionfish

• • • • • • • • • • • • • •

Lionfish are some of the most beautiful fish on the **reef** (a chain of rocks or coral near the surface of the water). They have brown, zebralike stripes that cover their body, head, and fins. These stripes act as **camouflage,** allowing lionfish to blend in while searching for their next meal. Their stripes, along with their long fins and the fleshy tabs above their eyes and below their mouth, make lionfish look like **algae** (small, plantlike organisms) growing on the bottom of the ocean.

Fearless

Lionfish don't have to worry too much about being eaten. Biting on a mouthful of lionfish would be very painful. Sharp spines at the end of some of their long fins pack a serious punch. These spines are hollow, and if they stab something, they inject strong **venom** (poison) that can paralyze or even kill a predator. Because these fish have such strong defenses, they don't need to hide and are commonly seen on the coral reefs of the Indian and Pacific Oceans.

Big Gulp

Lionfish feed on shrimp, crabs, and small fish. Sometimes they stalk their prey and expand their large **pectoral** (side) fins to corner their next meal. With a lightning-fast gulp, they suck their prey into their mouth and swallow them whole.

A Long Way from Home

Even though people may want to have lionfish for their home aquarium, lionfish can grow quite large, to around 15 inches, and quickly outgrow most fish tanks. Not knowing better, fish keepers have released lionfish too big for their tanks into the ocean. There are now lionfish found off the East Coast of the United States in the Atlantic Ocean, a world away from their native homes.

photo © James D. Watt/SeaPics.com • *Under The Sea Poster Book,* Storey Publishing

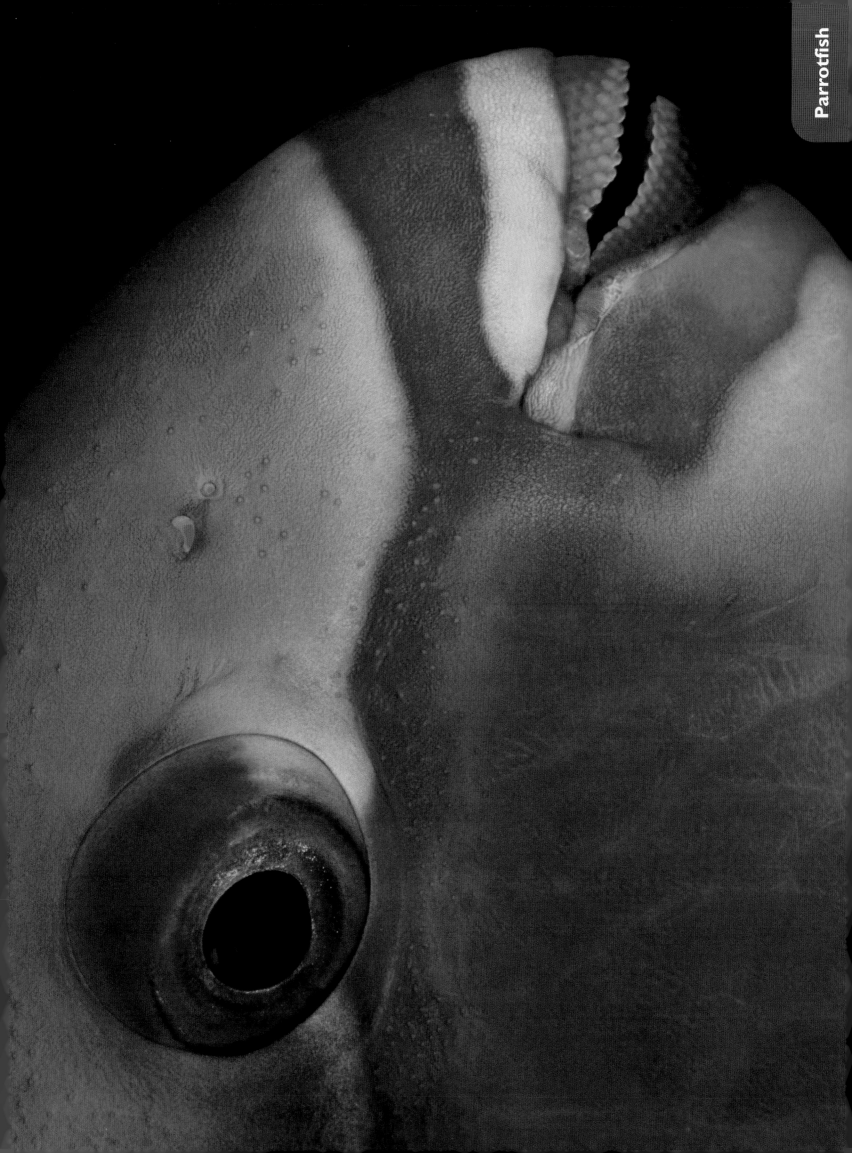

Parrotfish

· ·

With its large beak and colorful body, it's no wonder this animal was named "parrotfish." Parrotfish are among the largest fish commonly seen on the **coral reef** (a chain of coral near the surface of the water), ranging in size from 7 inches to 4 feet.

I Can't Believe I Ate the Whole Reef!

Parrotfish use that sharp beak to scrape **algae** (small, plantlike organisms) and **polyps** (animals that grow inside the coral) off coral and rocks. Using crushing plates in their mouth, the parrotfish mash any chunks of coral they bite off into fine sand. In fact, if you watch a parrotfish for a few minutes, you'll see several white clouds of coral sand being pooped out. Some scientists estimate that a single parrotfish can produce a ton of sand in one year! All of this chomping keeps reefs healthy by removing algae that would otherwise smother and kill corals.

A Cozy Blanket of Mucus

At night, when parrotfish are ready to sleep, they find a cozy cave where they can build a cocoon of mucus around their body. The mucous cocoon masks the scent of the parrotfish so predators won't be able to find them.

Just Who Are You?

Parrotfish are some of the hardest fish to identify because their shape, color, and markings change drastically as they get older. Most parrotfish are born as females, but they turn into males when they are fully grown. Others stay either male or female their whole lives. What complex fish!

photo © Franco Banfi/SeaPics.com • *Under The Sea Poster Book*, Storey Publishing

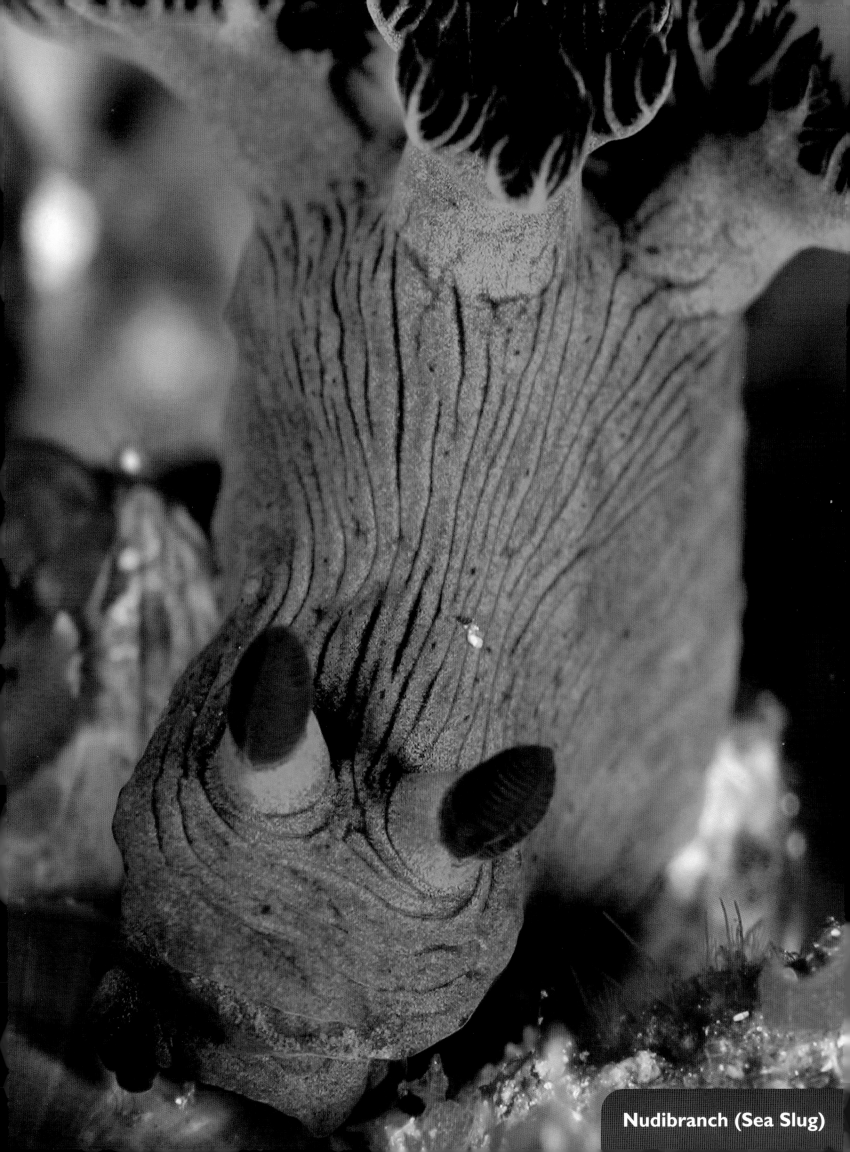

Nudibranch (Sea Slug)

Nudibranch (Sea Slug)

Even though they're related to garden slugs, these beautiful animals deserve a nicer name than "sea slug." This is why we prefer the scientific name **nudibranch.** Not only does it sound grand, but it also describes how their gills (the frilly blue "branches" on their back), instead of being inside a shell, are exposed (nude) to the open ocean.

Steal Some Protection

Because nudibranches have no shell to protect them, they have developed special ways to defend themselves. Many nudibranches eat sea **anemones** (uh-NEM-a-nees) and **hydroids** (relatives of corals and jellyfish) that have special stinging cells called **nematocysts.** When a nudibranch munches on these animals, it is able to keep the stinging cells intact. They pass right through the digestive system and then onto its back. If a predator tries to eat the nudibranch, these stolen stinging cells deliver a nasty wallop.

Her . . . Him . . . It?

Nudibranches are **simultaneous hermaphrodites,** which means they are both male and female at the same time. If one nudibranch finds another nudibranch, the two can mate. They will both produce babies, so each one is a mother and a father simultaneously!

A Special Diet

Many nudibranches eat only one or two kinds of animals. They use a specialized kind of tongue called a **radula,** which has tiny sharp teeth that tear into the prey. Some hunt other nudibranches by using the two "horns" on the top of their head to follow their distinctive slime trails. What a delicacy!

photo © James D. Watt/SeaPics.com • Under The Sea Poster Book, Storey Publishing

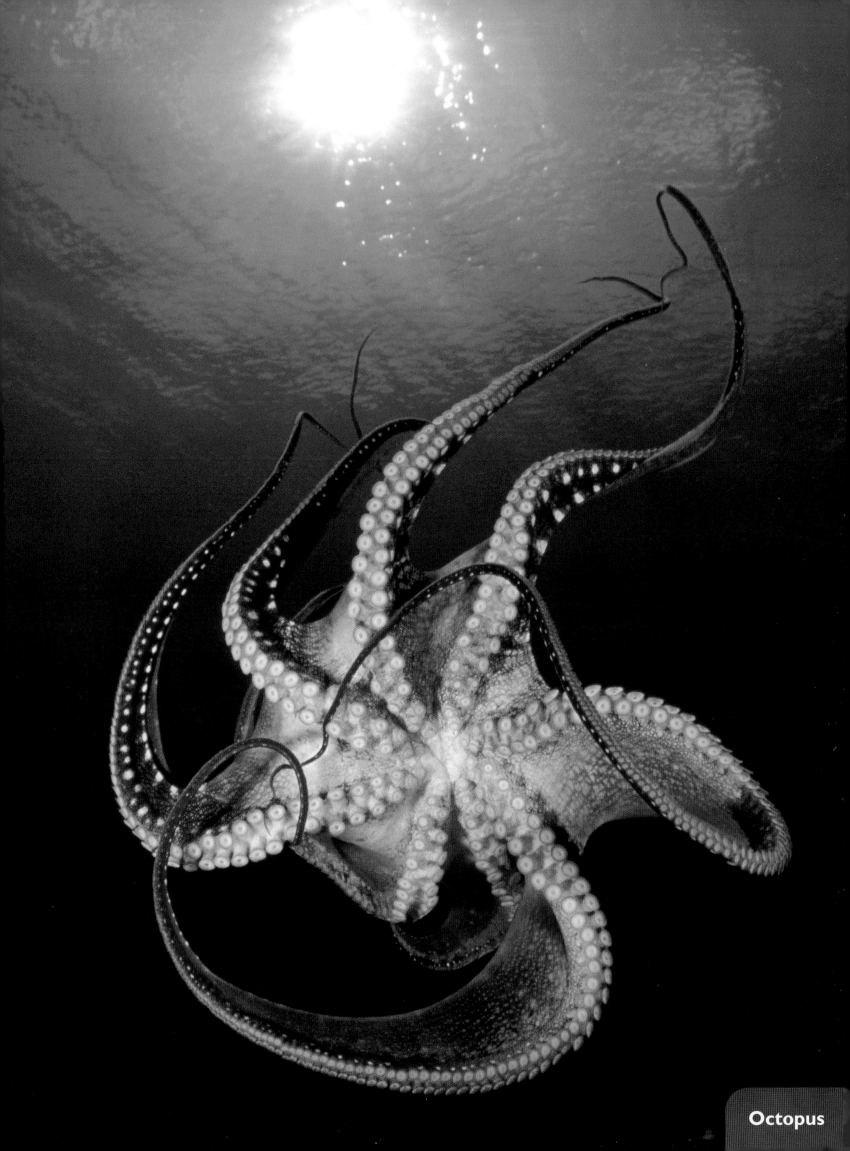

Octopus

Octopus

• • • • • • • • • • • • • • • •

This octopus looks as if it's all arms. Octopuses (or octopi) use eight sensitive arms, along with two eyes that see as well as ours, to explore the ocean world.

Who Needs an Invisibility Cloak?

Octopuses make an appealing meal to many ocean predators because they are one big tasty muscle. Octopuses must hide in order to survive, so they have become very good at disguising themselves. With special cells in their skin called **chromatophores** (kroh-MA-ta-fores), octopuses quickly turn just about any color to match their surroundings. They can also make the muscles in their skin look smooth or rough to match the texture of the substance they are resting on. Many SCUBA divers have been fooled by what they thought was a rock only to discover that it was an octopus!

Tricky Ink

When an octopus is scared, it may shoot out an ink cloud. Many people think the octopus hides in the cloud, but the real story is much more interesting. The ink cloud hovers in the water and actually looks like the octopus. Whatever is chasing the octopus will be confused by this and may try to attack the "ink octopus," allowing the real one to escape.

Jet-Powered

When an octopus wants to move quickly, it sucks water into its muscular **mantle** (body). It will then squeeze out the water with great force through its **siphon** (garden hose–shaped organ) and jet speedily away from harm.

photo © David B. Fleetham/SeaPics.com • *Under The Sea Poster Book,* Storey Publishing

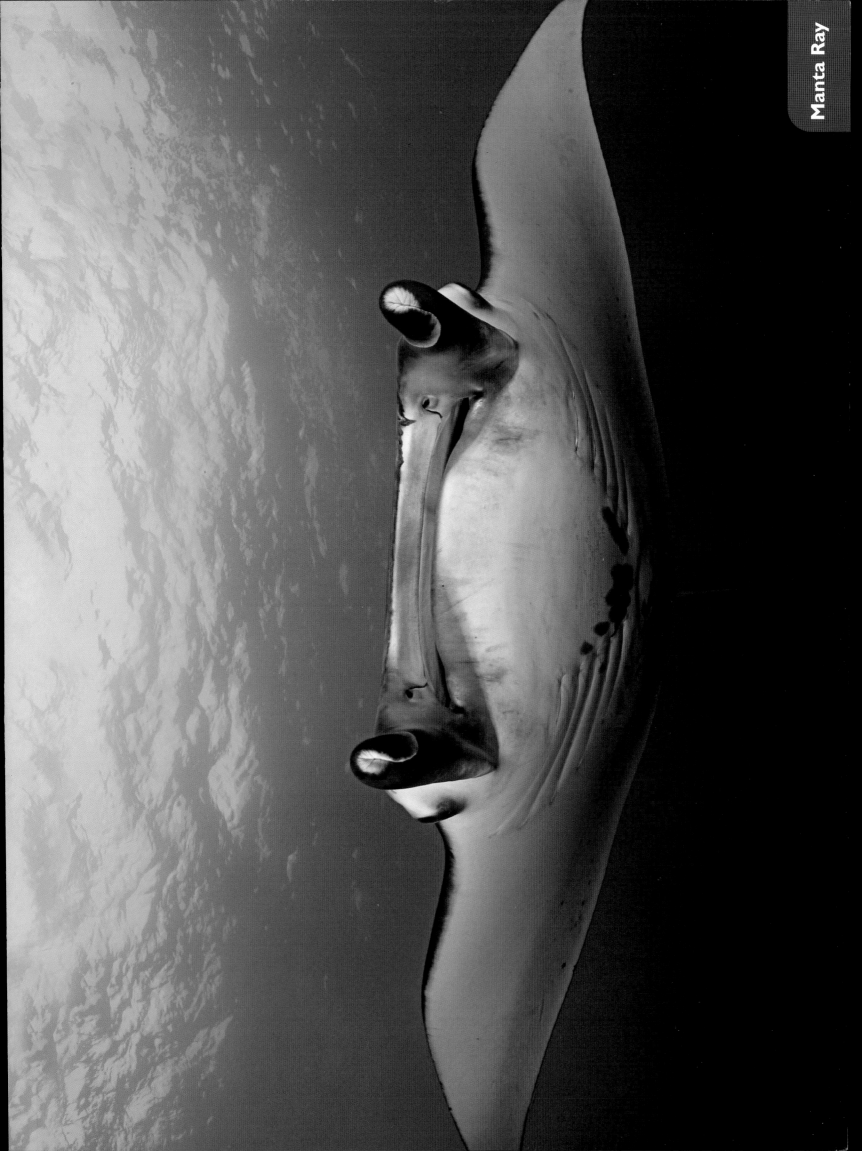

Manta Ray

The animal in the picture that looks like a big spaceship headed right for you is the majestic manta ray. Mantas are the largest ray in the world. They can reach more than 25 feet across and weigh up to 3,000 pounds (that's about how much a car weighs!).

It's Pretty Much All Black and White

Mantas are black to dark gray on their **dorsal** (top) side and mostly all white on their **ventral** (bottom) side. The technical term for the pattern is **counter-shading,** which simply means having a dark back and a light-colored belly. Counter-shading is common among animals in the open seas because it helps them hide where there is actually nothing to hide behind. If a predator looks at the manta ray from above, the dark ray blends into the deep sea. If a predator looks at the manta ray from below, the manta blends into the bright surface water.

Straining to Eat

Even though manta rays are big, they are harmless to humans and all other creatures except small plankton like **krill** (shrimplike animals about the size of a cricket). Mantas have no teeth, so when they find a **swarm** (group) of krill, they unfold their **cephalic lobes** (the curved bumps you see on each side of the head) to corner the animals. Then they open their mouth wide, straining thousands of krill at a time by using specialized gill supports in their throat.

Did You Know?

Even though they look a lot like their cousins the stingrays, mantas have no stinging spine on their tail.

photo © James D. Watt/SeaPics.com • *Under The Sea Poster Book,* Storey Publishing

Other Storey Titles You Will Enjoy

The Petting Farm Poster Book. Thirty pull-out posters feature beautifully reproduced full-color images of sweet chicks, ducklings, kids, lambs, calves, foals, piglets, rabbits, and more. The back of each poster contains fun facts about the animal's breed, habits, and history. 64 pages. Paperback. ISBN 1-58017-597-X.

Horses & Friends Poster Book. These 30 full-color posters feature horses with ponies, dogs, cats, goats, and other adorable companion animals. The irresistible posters are made for pulling out and decorating bedrooms, play rooms, lockers, or stables. 64 pages. Paperback. ISBN 1-58017-580-5.

Dream Horses: A Poster Book. Celebrate the beauty, the power, and the majesty of horses with 30 full-color large-format posters of horses in captivating, dream-like scenes created by master photographer Bob Langrish. Inspiring text accompanies each fantastical poster. 64 pages. Paperback. ISBN 1-58017-547-0.

The Horse Breeds Poster Book. Suitable for hanging on bedroom walls, in school lockers, or even in barns, these 30 posters show horses in a range of colors and sizes, at work and in competition. Facts about the pictured horse breeds are included on the back of each poster. 64 pages. Paperback. ISBN 1-58017-507-4.

Horse Games & Puzzles for Kids, by Cindy Littlefield. More than 100 puzzles, activities, riddles, quizzes, and games will keep young horse lovers happy and busy for hours. 144 pages. Paperback. ISBN 1-58017-538-4.

The Horse Farm Read-and-Play Sticker Book, text by Lisa Hiley; illustrations by Lindsay Graham. Five full-color laminated horse environments are the blank canvases for hours of play with 80 reusable vinyl stickers. Text teaches the basics of equine care. 16 pages. Paperback. ISBN 1-58017-583-X.

These and other books from Storey Publishing are available wherever quality books are sold or by calling 1-800-441-5700. Visit us at www.storey.com

The mission of Storey Publishing is to serve our customers
by publishing practical information that encourages
personal independence in harmony with the environment.

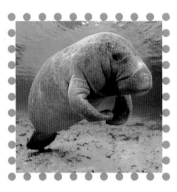

Edited by Deborah Balmuth and Sarah Guare
Art direction and cover design by Vicky Vaughn
Text design and production by Kristy MacWilliams
Cover photograph © Doug Perrine/SeaPics.com
Additional interior photographs © James D. Watt/SeaPics.com, title
and intro pages; and © Doug Perrine/SeaPics.com, this page

Copyright © 2005 by Storey Publishing, LLC

All rights reserved. No part of this book may be reproduced without written permission from the publisher,
except by a reviewer who may quote brief passages or reproduce illustrations in a review with appropriate
credits; nor may any part of this book be reproduced, stored in a retrieval system, or transmitted in any form
or by any means — electronic, mechanical, photocopying, recording, or other — without written permission
from the publisher.

The information in this book is true and complete to the best of our knowledge. All recommendations are
made without guarantee on the part of the author or Storey Publishing. The author and publisher disclaim any
liability in connection with the use of this information. For additional information please contact Storey
Publishing, 210 MASS MoCA Way, North Adams, MA 01247.

Storey books are available for special premium and promotional uses and for customized editions.
For further information, please call 1-800-793-9396.

Printed in China by Elegance

10 9 8 7 6 5 4 3 2 1